IMAGES
of America

READINGTON TOWNSHIP

On the cover: This photograph of a parade celebration was taken on Old Highway (Route 28) in Whitehouse during the 1920s. Proudly carrying Old Glory are students from one of the township's one-room schoolhouses, Centerville School. On the left side of the flag, from left to right are unidentified, Elizabeth Van Arsdale, Edna Hoffman Space Westcott, Alice Natter, and unidentified. (Courtesy of Stephanie Stevens.)

IMAGES
of America

READINGTON TOWNSHIP

Readington Township Historic
Preservation Commission and
Readington Township Museum Committee

ARCADIA
PUBLISHING

Copyright © 2008 by Readington Township Historic Preservation Commission and
Readington Township Museum Committee
ISBN 978-0-7385-5679-6

Published by Arcadia Publishing
Charleston SC, Chicago IL, Portsmouth NH, San Francisco CA

Printed in the United States of America

Library of Congress Catalog Card Number: 2008920533

For all general information contact Arcadia Publishing at:
Telephone 843-853-2070
Fax 843-853-0044
E-mail sales@arcadiapublishing.com
For customer service and orders:
Toll-Free 1-888-313-2665

Visit us on the Internet at www.arcadiapublishing.com

This is the seal of Readington Township.

CONTENTS

ACKNOWLEDGMENTS

When the historic preservation commission and museum committee decided to join together to do a book on Readington Township, little did anyone know where the journey would lead and what riches would result. Over a nine-month period, current and past residents eagerly shared their memories of the places and people of the community that they call home. The result of this effort is a book by current and past residents for the future residents of the township.

The book committee would like to express a giant thank-you to all those who shared their photographs to make this project possible. A special note of appreciation is extended to historians Stephanie Stevens and John Kuhl for sharing their collections and historical knowledge of the township and to Paul Kurtzenberger for providing many wonderful photographs.

The challenge in presenting the images for the book was the lack of information on many of the photographs, be it individuals within a group photograph or the name of a specific place. The book committee did its best to ensure that the information for each picture was accurate and apologizes in advance for any errors or omissions. The committee members encourage readers to share their information with them to round out the story of the images presented.

The members of the book committee that gave their time and talent to make this book a reality are as follows: Patricia Fisher-Olsen, Betty Ann Fort, Mary Erin Brennan, Frank Gatti, Kristin Gatti, Donna Grohoski, Richard Grohoski, James Horvath, Robyn Rasmussen, and Tricia Doyle Sarrow.

INTRODUCTION

Readington Township, the land that was originally purchased from the Lenape Indians, is the third-largest township in the state of New Jersey. Many of the area's characteristics that brought the original settlers to the township still attract the present-day resident. Comprised of multiple hamlets and villages, each of which were settled near a waterway, railroad, or fertile lands, the township became a mosaic of families, farms, agriculture, business, religion, education, and most importantly, a strong community.

Mainly out of necessity, the villages sprung up along streams or rail lines. The villages that were built up by the railroad lines were very prosperous because it was convenient to ship products, including milk, peaches, or wagon wheels, to distant markets, such as New York City. Products from Readington were shipped as far south as the swamps of Georgia, where extra-large wagon wheels were a commodity and always welcomed. Other villages and hamlets sprung up along a race where mills could utilize the power of the flowing water and livestock had a constant source of fresh drinking water.

The early settlers bought up major pieces of the landholdings, some amounting to thousands of acres. Some parcels were subdivided and sold off publicly. Others were subdivided and deeded out among the many children of the families that farmed them. Prominent landowners included the Cole, Schamp, Lane, and Pickell families, to name just a few. Many streets and parks in Readington Township today hold the names of these families in tribute and remembrance. Some early families existed simply by farming their land while others prospered by owning and operating their businesses, such as taverns, mills, or stores.

The Pickell family had an addition built on the side of their house in Whitehouse, which served as a general store. Another member of the family opened a millinery shop in Whitehouse Station. Casper Berger owned and operated a tavern in Readington, providing the village with a much-needed place for social gathering. Abraham Van Horne owned and operated a tavern in Whitehouse, which was a stagecoach stop picking up and dropping off travelers on the run between Easton, Pennsylvania, and New Brunswick, New Jersey. The Dilts and Wyckoff families ran the local mercantiles in the Three Bridges area. Each of these families had homes in these villages and contributed greatly to the development and strengthening of the village center.

Readington Township also made a significant contribution to the progress of the nation's struggle for independence. Gen. George Washington and his men passed through various parts of the township several times, setting up camp and planning war strategies. One Readington resident, Col. David Schamp, was known as "Washington's spy" and served as a captain in Washington's secret service. Another resident, John Melhelm, opened his home to Washington so

often that the general used the Melhelm house as his address to receive important Revolutionary War correspondence. The early residents of this township contributed to the greater good then and still come together today when faced with important issues.

Each village had its own sense of community, just as each village had its own blacksmith or church, deeming it self-sufficient. Travel outside the village was not necessary and, as a result, did not occur often. Even social events were held within the village boundaries at someone's home, the church, the firehouse, a school, or a local hall. Today travel through and among the villages is an everyday event, and people are quietly reminded of the way life used to be every time they drive across a one-lane bridge or pass through the heart of one of these early village centers.

Today's residents of Readington Township often still identify with the villages they call home. They still attend church at the Rockaway Reformed Church or Our Lady of Lourdes. They are members of the fire company in Three Bridges or in Readington. Their children attend Whitehouse School or Three Bridges School. The people throughout the township will gather today to watch a parade on County Route 523, just as they came together for Fourth of July parades or political rallies in the early days of the township.

The people who originally settled and shaped Readington Township are long gone, but many of their descendants still reside in the villages inhabited by their forefathers. The memories, histories, and love of this township have been passed from generation to generation and to the township's newer residents. A snippet of what village life was like in years past has been captured in this book. *Readington Township* was created by residents of the community who felt passionately about capturing a bit of history and telling the story of how the township, with all its hamlets and villages, came to be.

Many generations will inhabit the old and new homesteads of Readington Township and changes will continue to occur, but the strong sense of community that has been ever present in this township will hopefully continue in perpetuity.

One

READINGTON VILLAGE

The village for which Readington Township was named was settled in 1730 by royal charter. It was named after John Readings and encompasses only a small portion of the 45-square-mile township. Like many villages, it was settled near a water source, the Holland Brook, which provided power to operate saw- and gristmills and was a source of water for the people, their crops, and animals. As is true today, the residents of this village came from all over and brought various cultural influences to this burgeoning village. The Dutch and English immigrants contributed the most to the architectural styles of the houses and barns, many of which still exist today. With all the basics needed for everyday life, this village had a sawmill, a gristmill, a blacksmith, a general store, a one-room schoolhouse, a church, and a cemetery.

Many of the families who came to Readington Village worked and lived off the fertile land. Some of the most prominent landowners and contributors who helped shape the village were the Berger, Lane, Cole, and Schamp families. Casper Berger built the inn located directly across the road from the Readington (Dutch) Reformed Church, on land that he granted to the congregants to erect the church. He also owned a mill and the store, thus wielding great influence over the small village.

Like the Casper Berger Inn, many original homesteads, barns, schools, and other structures still exist today. Many have disappeared due to fire or neglect, and many of the families, memories, and histories have also disappeared. Over the years, many more people settled into Readington Village and changed its landscape, but there is much that has remained behind to remind Readington's current and future residents of the beginnings of this historic place where a small community once thrived.

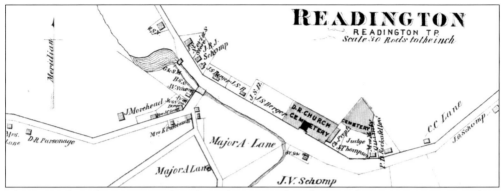

This map of Readington was taken from the 1873 *Atlas of Hunterdon County New Jersey from Recent and Actual Surveys and Records under the Superintendence of F. W. Beers*, Comstock and Cline, 36 Vesey Street, New York.

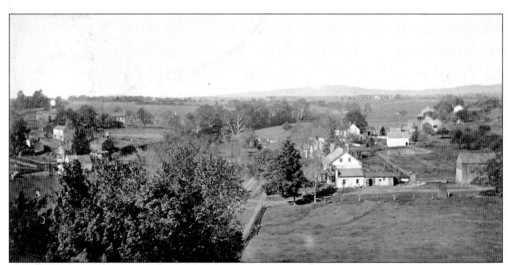

This aerial view of the village of Readington was captured from inside the steeple atop the Readington Reformed Church on Readington Road, looking southwest toward what is now County Route 523. From the church steeple to Cushetunk Mountain in the far distance, one can see the original farmhouses, barns, a one-room schoolhouse, and a lot of green, open space surrounding this small village. In the foreground is the Berger-Cole house and barns. The family has been in the village since its inception.

Local dairy farmers used to haul their milk to the old creamery that once stood alongside the Holland Brook and only a stone's throw away from the gristmill. Well into the 1900s, Frederick Peabody, standing next to this horse and wagon, was in charge of the Readington Creamery Association where local dairy farmers deposited their fresh milk. To keep the milk cold, ice was brought to the creamery from a farm in the next county. This building exists today as a private residence.

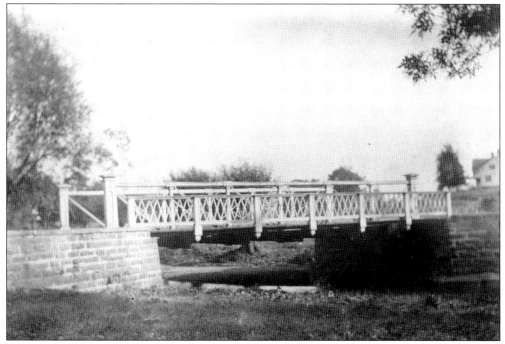

The old iron bridge over the Holland Brook was located in the center of the village of Readington along the old route to New Brunswick. A mileage marker was present on its abutment.

The building in the center was the Readington Store around 1849. The house on the left was the 18th-century home of the mill owner and is skewed to the road, indicating the way the old road ran. It overlooks the mill site that was located across the road.

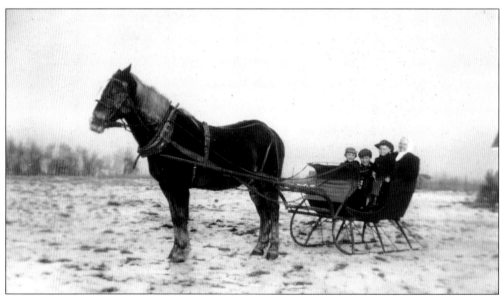

Bertha Vail Force and her grandchildren Junior, Eddie, and Donald Force are seated in a one-horse open sleigh pulled by Wilbur. This photograph was taken at the family farm on Pulaski Road around 1950.

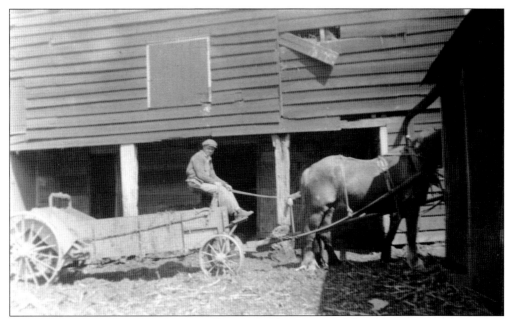

Seated on his horse-drawn wagon is William Harold Hageman of the Hageman farm, located on Hillcrest Road just beyond the limits of Readington Village. The original owner of this farm was a grandson of Aray Van Guinea, founder of the German Lutheran church at Potterstown, now the Zion Lutheran Church in Oldwick.

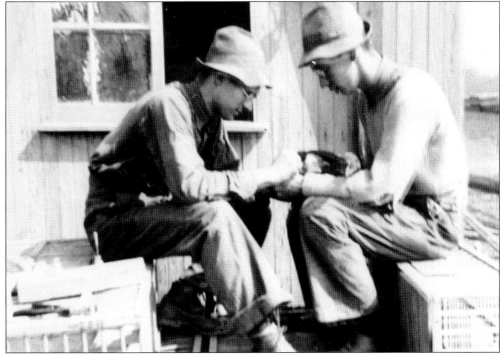

Members of the Readington Local, two brothers sit on the chicken crates and are performing blood testing on their hens. The Dairymen's League of Readington Local was organized in 1917 and incorporated in 1922. More than 64 members had signed the bylaws over its lifetime.

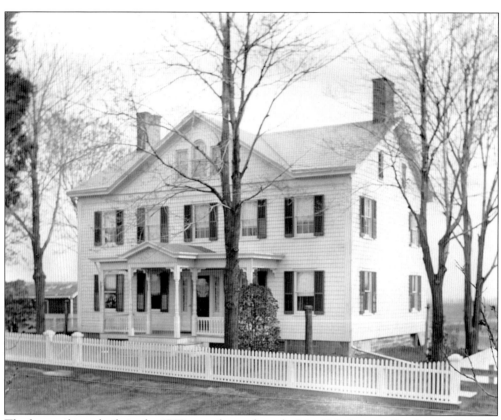

The house above, built in the 1700s, was located on the Van Pelt farm on Readington Road. It was the home of Herbert Van Pelt, a well-known and colorful resident of Readington Village. The house still exists today as a private residence. The photograph below is a pastoral view of the rear of the Van Pelts' house, numerous barns, and outbuildings.

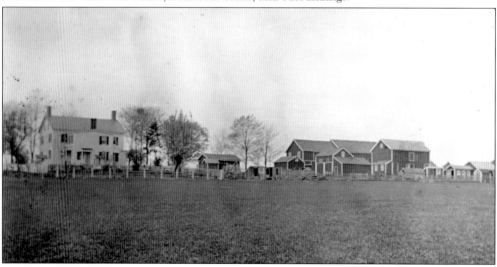

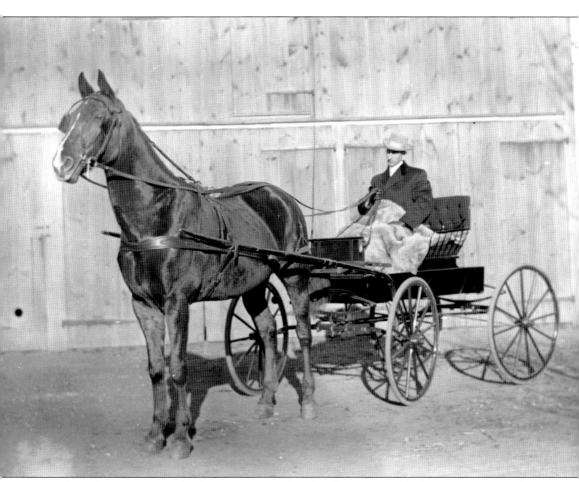

Posed in front of one of the large barns on the Van Pelt farm is Herbert Van Pelt and his horse-drawn carriage on a cold winter day. Van Pelt held offices of importance during his lifetime, but he is most remembered for being an auctioneer. He inspired a regular cult of followers to his farm auctions, where he regaled the audience with stories of yesteryear.

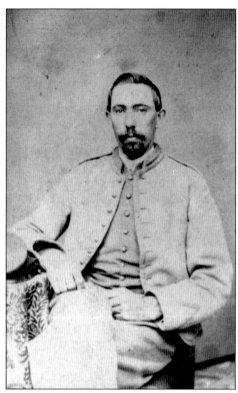

Readington resident Edward Hill poses in this 1862 photograph wearing his Veteran's Reserve Corps uniform, possibly of Civil War vintage. Hill suffered many injuries, including being run over by a cavalry horse, which resulted in a serious head laceration, injury to his brain, and eventual loss of hearing. In 1863, he sustained another serious wound to his right foot, caused by an ax. However, the eventual cause of his demise in 1865 was a stroke.

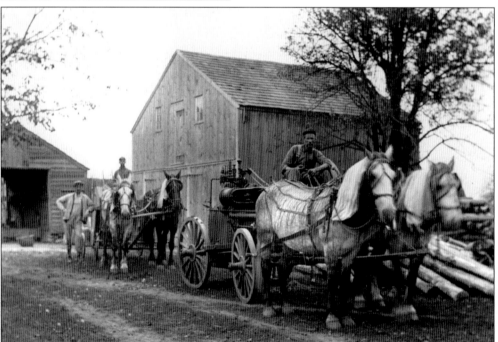

Two separate teams of draft horses are ready to depart this barnyard in the Readington Village area for a day's work. The wagon being pulled by the draft team is loaded with a gasoline engine, which may have been used for the milling of corn or wheat.

Readington resident Lemuel Hockenbury was a private in the New Jersey Volunteers Company A of the 15th Regiment during the Civil War. He was born in 1846 and mustered into service at the tender age of 14. He later succumbed to wounds received in action and died in a hospital in Virginia at age 18 in 1864.

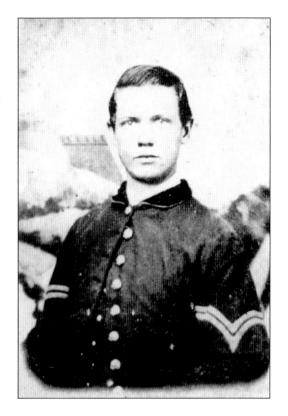

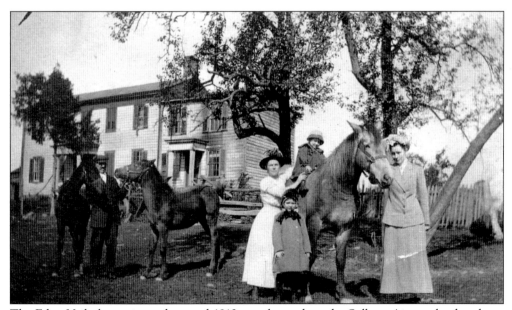

The Eden Vail place, pictured around 1912, was located on the Solberg Airport land and was home to Eden Vail and his family. In front of the house with their horses are, from left to right, Vail, his wife, Bertha, and daughters Grace, Thyra, and Lizzie.

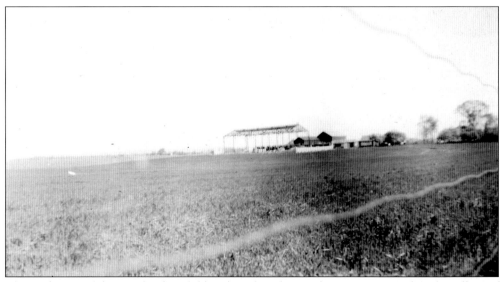

This is the site of the new landing field and airplane hangar being constructed in the village of Readington on the Solberg Airport property. In talking about the airport, one farmer remarked, "What a thrill it was for us to see an airplane—those are some of the things you never forget." The airport still operates today and is home to one of the largest hot-air balloon festivals in North America, drawing thousands of people to Readington each year.

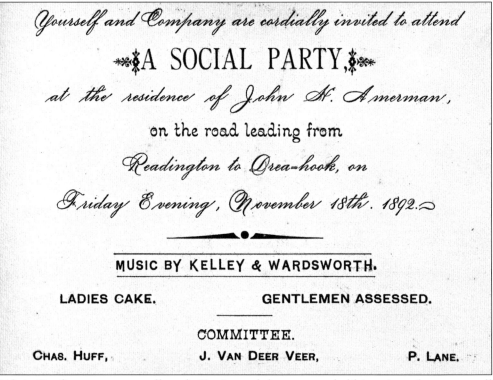

Life in Readington was not all work. Parties and dances were held in private homes as well as public buildings and were well attended. Formal printed invitations such as this one were customary.

The Readington Village schoolhouse was built in 1849 and was the second school built in the village. After the third new school (rear, right) was built, this older schoolhouse was bought by the owner of a nearby farmhouse, who later lent it to the Readington Volunteer Fire Company for use as its first firehouse. It still stands today at the intersection of Hillcrest and Centerville Roads and serves as the garage of a private residence.

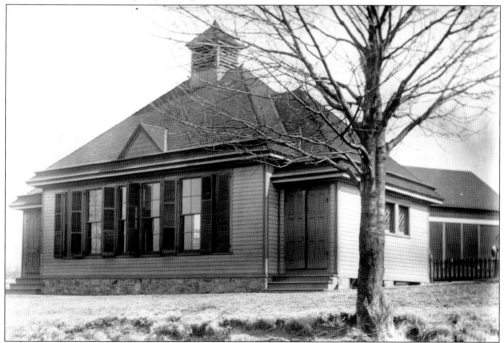

The new Readington Village schoolhouse, located on Centerville Road, was built in 1903 not far from the site of the original schoolhouse at the bottom of the hill. Today it joins a handful of early schoolhouses that have been made into private residences.

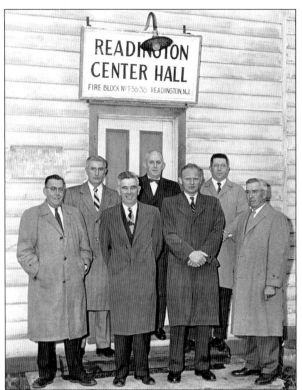

Standing in front of what was the old Readington schoolhouse are the charter members of the Readington Volunteer Fire Company. The owner of the schoolhouse lent it to the fire company as a place to house its trucks and equipment. Pictured from left to right are Emory Barber, unidentified, Fred Cole, unidentified, John Bettner (first president), Emil Spildoren, and Robert Cole.

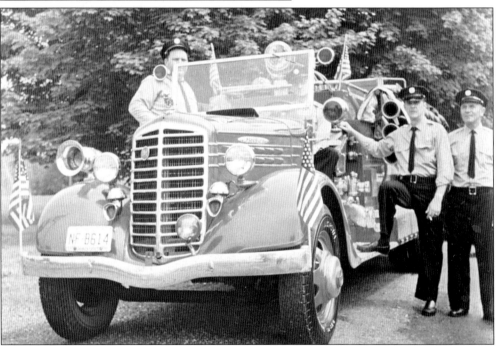

Front and center in this photograph is the first fire truck purchased by the Readington Volunteer Fire Company in 1958. The members of the Readington Volunteer Fire Company pictured here are, from left to right, Paul Terrechiano, Ed Hammer, Cliff Swick, and Steve Nicke.

In this photograph taken in the early 1970s, these two fire trucks are parked in front of the new Readington firehouse. The Ford truck on the right was given to the Readington Volunteer Fire Company by Glen Gardner and was later returned when Readington was able to purchase its second truck.

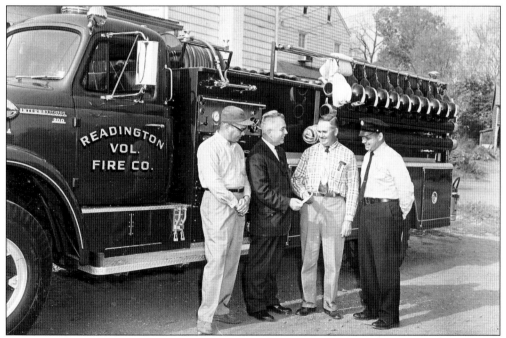

Standing by their new fire truck in front of the old Readington firehouse are members of the Readington Volunteer Fire Company being presented with a check for $14,000 on October 29, 1963. From left to right are Jerome Niles (fireman), Freese Hess (banker), Harold Hageman (fireman and treasurer), and Dick Krautwald (fire chief).

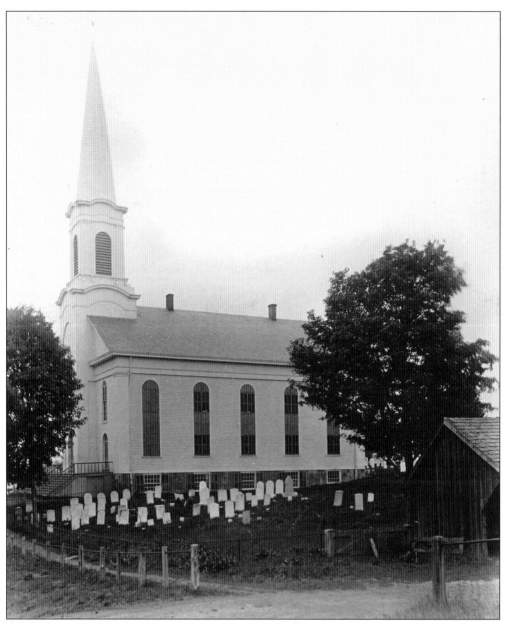

Readington Reformed Church was founded in 1718–1719 by the Dutch settlers of North Branch in Somerset County. The preacher of the first sermon was the famous Theodorus Jacobus Frelinghuysen, whose progeny have filled some of the highest offices in New Jersey and the United States. By 1739, the congregation relocated three miles west to the village of Readings. That church building was replaced in 1833 by a frame church that later burned to the ground in 1864. The faithful congregants rebuilt immediately, and worshipers continue to meet in that church today. The second *domine* (Dutch for preacher) was Jacob Hardenberg, who was a strong patriot during the Revolutionary War. He also became the first president of Old Queens, known today as Rutgers, the State University of New Jersey. The tall steeple shown in this picture was destroyed by a cyclone on January 3, 1913, and was replaced with the shortened version that adorns the church today.

Two

WHITEHOUSE, MECHANICSVILLE, POTTERSTOWN, AND NEW BROMLEY

Whitehouse Village, situated near the confluence of the two branches of the Rockaway River, was named after an old tavern built by Abraham Van Horne in the early 1700s that had white plastered walls. This tavern was a public house and known for its entertainment value, as people often stopped there when traveling by stagecoach from Easton, Pennsylvania, to New Brunswick, New Jersey. Like other villages in the township, Whitehouse had the usual businesses, including a sawmill, a gristmill, a blacksmith shop, a wheelwright, a lumber and coal yard, several shops, a post office, a church, and family dwellings. Many prominent families settled in Whitehouse, including the Van Hornes, Pickells, Durlings, Hoffmans, and Patersons.

About a mile east of Whitehouse Village is the small hamlet of Mechanicsville, named after the tradesmen who worked and settled there during the 1800s. This hamlet had a Methodist church, a store, a few mechanical shops, and several family homesteads.

Across the Rockaway River and north of Whitehouse Village is the tiny village of New Bromley. It is within this village that Gen. George Washington stayed with the Melhelm family at their home during the American Revolution. Just west of Whitehouse Village is the village of Potterstown, one of the oldest settlements in Hunterdon County. Here one could find a blacksmith, a wheelwright, a storehouse, two taverns, and a pottery, which gave the village its name. Most of these are now gone, leaving early village life barely detectable today, but not forgotten.

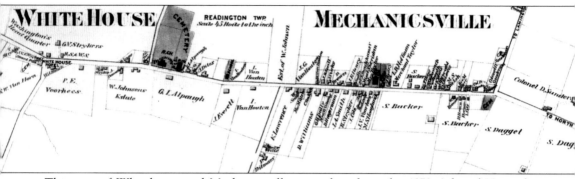

This map of Whitehouse and Mechanicsville was taken from the 1873 *Atlas of Hunterdon County New Jersey from Recent and Actual Surveys and Records under the Superintendence of F. W. Beers*, Comstock and Cline, 36 Vesey Street, New York.

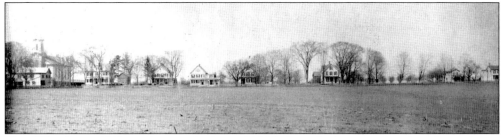

This Whitehouse Village photograph shows Old Highway looking north, taken from what is now Route 22. On the left are the White House United Methodist Church in the background and the Van Syckel house and barn in the foreground. The Pickell house and store is the fourth structure from the left. On the extreme right is a small house, located two doors west of East Whitehouse Fire Company.

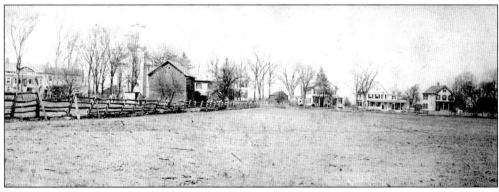

This picture depicts a closer look at Whitehouse Village. Note the open pastures that are now gone because of Route 22 and the businesses along it.

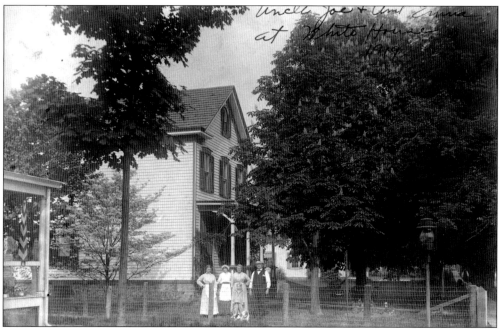

Joe and Emma Lewis, shown here on the right with their friends and dog, built this house located on Old Highway in the 1870s. They left this house to their nephew Harold Swartout and his wife, Lillian, who lived in it for more than 50 years. As a young couple, the Swartouts traveled out to the country, as they called Whitehouse, for visits.

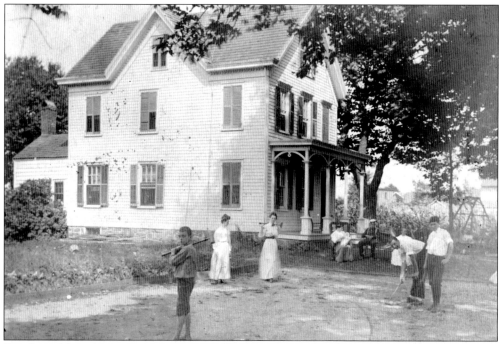

Family and friends are enjoying a game of lawn croquet. This classic folk Victorian house is a home located on Old Highway in the East Whitehouse–Mechanicsville section of the township and was the home of Fannie Emley, a member of the Pickell family.

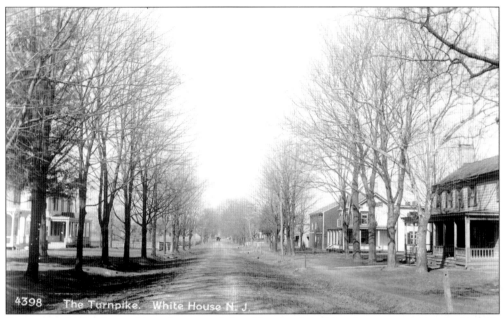

The original New Jersey Turnpike, one of the oldest roads in New Jersey, runs directly through Whitehouse-Mechanicsville. Although it was called a turnpike, the portion that ran through Hunterdon and Warren Counties was never in sufficient repair to warrant collecting tolls. In 1838, the road was surrendered to local townships, and maintenance was placed in the hands of local farmers, who deemed repairing the road as not a priority.

C. P. Oliver's dwelling in Whitehouse is shown here. The classic Greek Revival structure with a Jersey facade addition was centrally located on the New Brunswick-Easton Turnpike. It is flanked by a pair of snowball bushes, climbing roses, and informal lawn chairs on the columned porch. It comes with only one cat, however.

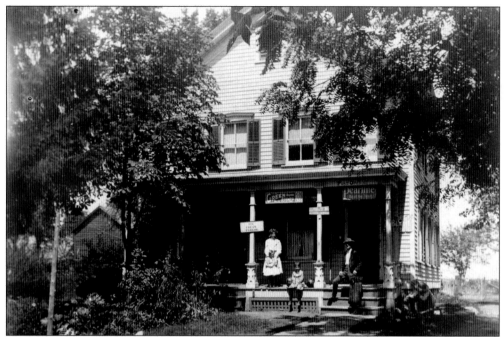

Since traveling more than a few miles was difficult, every hamlet had its general store to provide necessities. Often the general store housed the local post office, as did John Lane's necessities store in Whitehouse, shown here in an early-20th-century photograph.

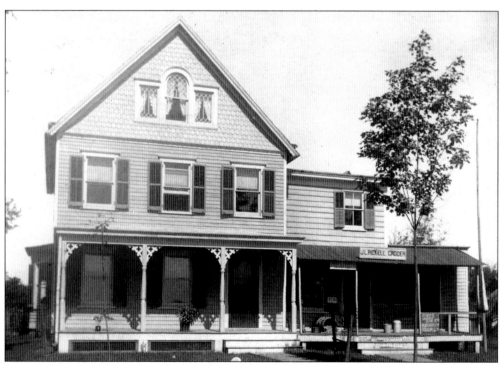

John L. Pickell kept a general store in Whitehouse in 1910. His wife, Elia, continued to run the store after his death a few years later.

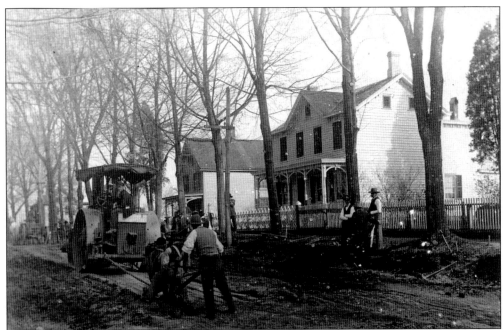

Seen here in earlier days, the Readington Road Department is packing down the dirt road surface on Old Highway while providing entertainment for the locals. Take note of the men operating the machines in their hats and vests. Their attire seems more appropriate for an office than for operating machinery.

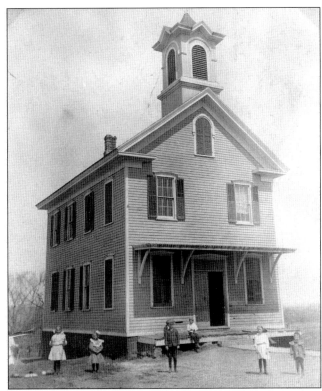

Children gather outside the Whitehouse schoolhouse. The boy in the center is George Malcolm Ryman. The schoolhouse was built in 1871 and was the third schoolhouse in Whitehouse. The earlier ones were built in 1808 and 1835.

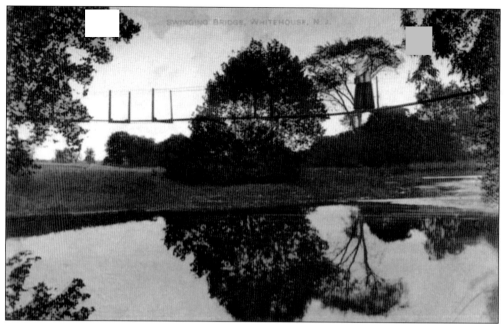

Pictured here around 1905, the swinging bridge, which spanned the Rockaway Creek behind the Whitehouse United Methodist Church, was not too far from the Greenbank. Greenbank was a popular place for families to gather for a Sunday picnic after church.

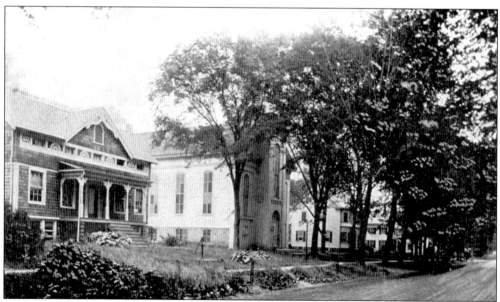

Long before paved roads became commonplace, this view shows Old Highway as it crosses through the village center of Whitehouse. Looking east, the Methodist church and parsonage sit behind the row of elm trees that once lined the walkways.

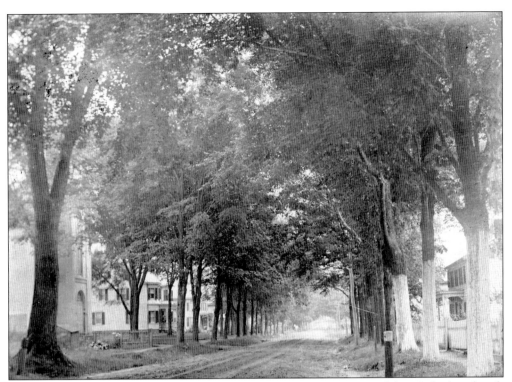

The elm trees on Main Street (Old Highway) in Whitehouse in front of the Methodist church have been painted with a solution in an attempt to halt the spread of Dutch elm disease, which destroyed millions of elms in the United States in the 20th century.

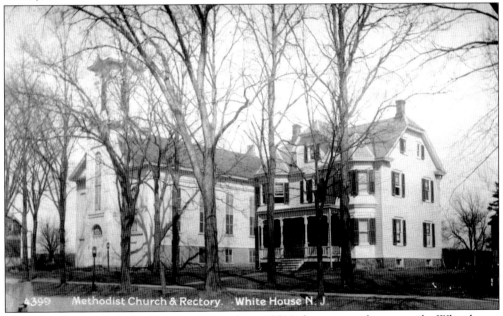

The Whitehouse Methodist Episcopal Church on Old Highway is now known as the Whitehouse United Methodist Church. The original church stood where the Methodist cemetery is now located. It was sold when the building in this photograph was opened in 1864.

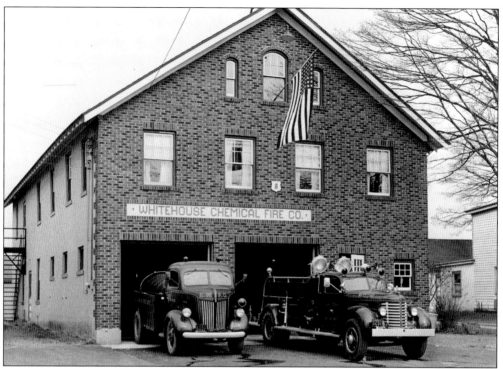

Built in 1844 for the congregation of the Methodist Episcopal Church of Mechanicsville, this building was sold in 1867 and used as a blacksmith shop. In 1940, the Whitehouse Chemical Fire Company converted it into a fire house. Members of the East Whitehouse Fire Company stand next to their 750-gallon tanker. Converted from an old oil truck, this tanker was dedicated and presented to the company in March 1955.

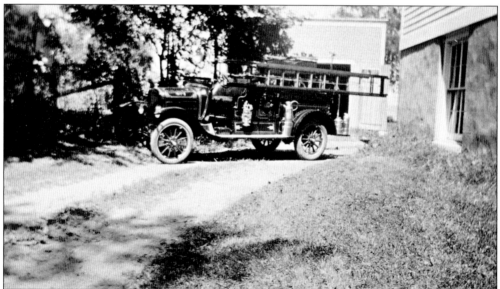

Kept in the horse-and-wagon shed behind the church, the first motorized fire truck for the East Whitehouse Fire Company is ready for the Labor Day parade in Lebanon. Photographed in 1924, the truck is parked at the rear west side of the Whitehouse United Methodist Church.

This picture shows an early intersection of the New Jersey Turnpike looking west toward Pickell Mountain (Cushetunk Mountain) and Main Street (County Route 523) coming in from the left as the Y in the intersection and curving downhill toward the Rockaway Creek. In the distant left of the picture is the S. W. Van Horne residence and barn.

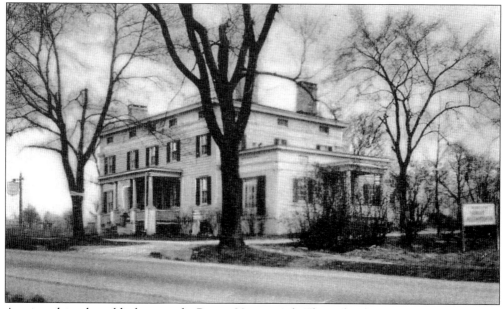

As viewed in this old photograph, Route 28 is paved. The Whitehouse Hotel is now more accessible to travelers. Today this building is the sales office for Coldwell Banker Realtors. The back of this building now fronts Route 22.

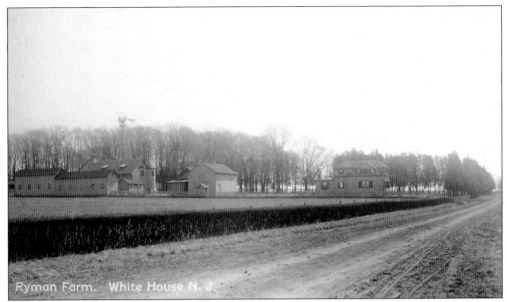

Ryman Farm. White House N. J.

The 50-acre farm on the original New Jersey Turnpike stayed in the Sanderson family for over 100 years until Kencyl L. Ryman purchased the property in 1906 to operate a dairy and horse farm. After Ryman's death, his wife, Carrie, opened a tearoom in the house in 1928. In 1935, her son George Malcolm (Mike) made the tearoom into a restaurant, the Ryland Inn, which became well known throughout New Jersey for its fine food and elegant service. The restaurant remained in the family for over 50 years, becoming a four-star restaurant and entertaining many national and local dignitaries. In June 1989, Paul L. Ferber acquired the inn and its 50 acres for the construction of office buildings. In cooperation with Readington Township officials, the decision was made to restore the inn to its former style. In 1991, chef Craig Shelton purchased the inn and continued its elegant tradition. The inn closed in 2007.

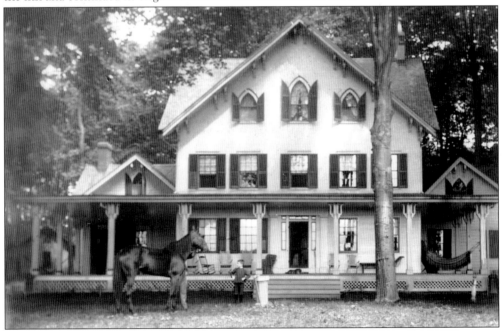

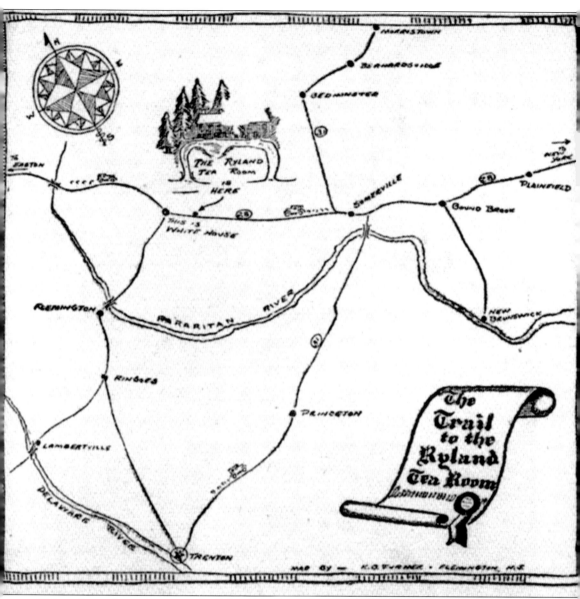

This trail map shows the way to the Ryland Tea Room, located on Old Highway 28 in Whitehouse. Carrie Ryman opened the tearoom in 1928. This trail map draft shows the surrounding area prior to the building of Route 22. The tearoom later became known as the Ryland Inn.

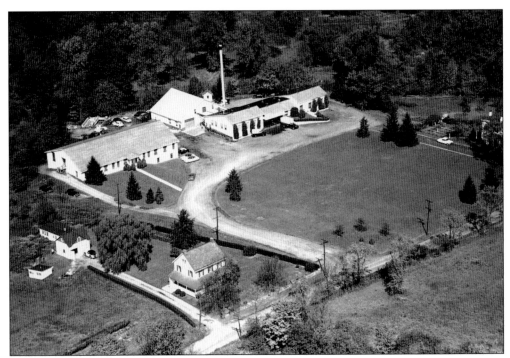

The Durlings' creamery expanded over the years and became the Durling Farms dairy business. In 1966, Carlton Durling expanded the business by establishing Quick Check convenience stores, a successful and well-known New Jersey business still based in Whitehouse. The dairy business was renamed Readington Farms.

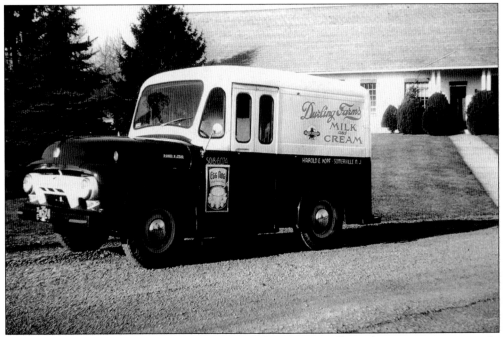

During the first half of the 20th century, the Durling Farms milk trucks were a common sight throughout New Jersey as they delivered milk to homes and businesses.

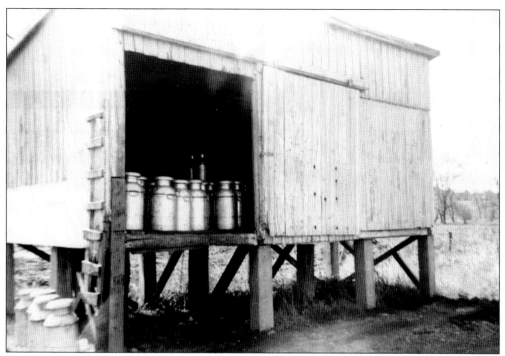

A dark shed kept milk cans out of the hot sun, as they await pick up along the Rockaway Valley Railroad line near Whitehouse.

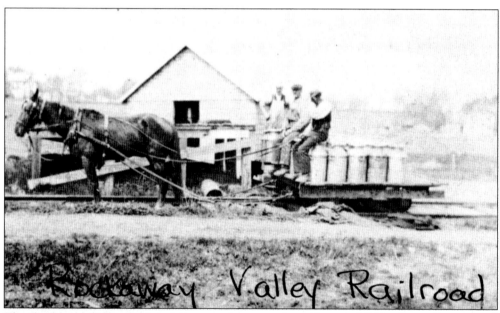

The Rockaway Valley Railroad line ran between the villages of Whitehouse Station and Morristown from 1888 to 1913. Founded by prosperous Readington and New Germantown (Oldwick) farmers, the line was a convenient way to bring peaches, milk, and other produce to urban markets. After the line's demise in 1913, dairymen still used the track, shipping their milk to Whitehouse Station on a horse-drawn flatcar, as shown above.

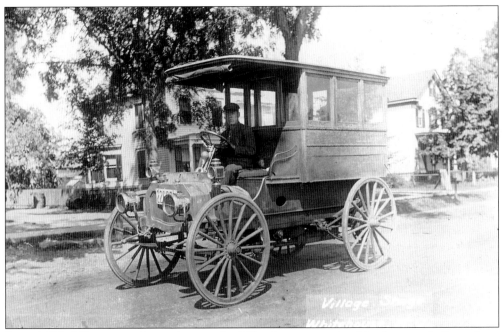

Bertzel "Joby" Runyon is shown driving the Whitehouse stage in this photograph from about 1915. The stage was used to transport passengers to and from the railroad in Whitehouse Station about a mile away.

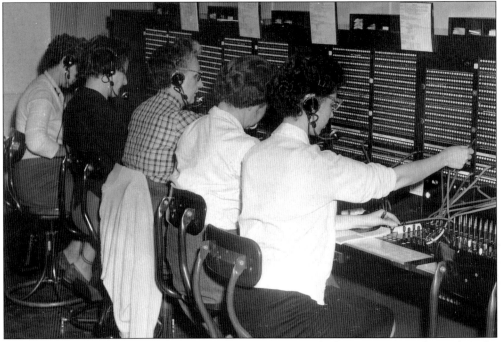

The Whitehouse telephone exchange of the New Jersey Telephone Company, located at the intersection of Old Highway, County Route 523, and Route 22, placed calls for its customers until the township upgraded to dial service in 1962. Seated from left to right are Alberta Schuetz, Virginia Metzler, Vi Gasman, Dot Miller, and Eileen ?.

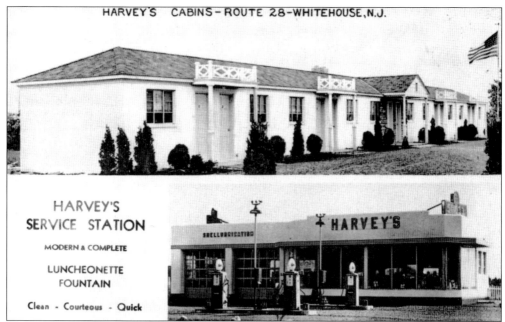

HARVEY'S CABINS - ROUTE 28 - WHITEHOUSE, N.J.

HARVEY'S
SERVICE STATION

MODERN & COMPLETE

LUNCHEONETTE
FOUNTAIN

Clean - Courteous - Quick

Everything the motorist needed was provided by Harvey's Cabins and Service Station on Route 28 in Whitehouse. The 10 cabins were advertised as being the last word in modern roadside sleeping places, boasting heat, showers, and all the modern conveniences. As well as filling up his tank, the motorist could stop for lunch and have a soda.

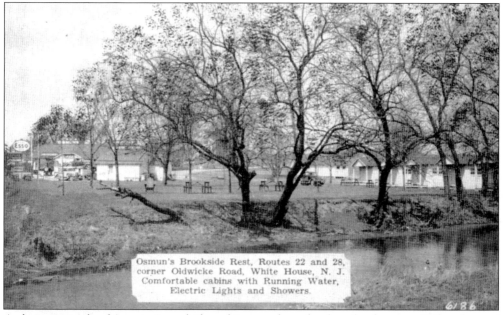

Osmun's Brookside Rest, Routes 22 and 28, corner Oldwicke Road, White House, N. J. Comfortable cabins with Running Water, Electric Lights and Showers.

A classic example of America's roadside architecture brought about by the automobile culture of the 20th century was Osmun's Brookside Rest located on Route 22. Here neat clustered cabins offered travelers comfortable accommodations to rest on their journey in a location convenient to food and fuel. The Esso station shown on the left of the photograph is still a sight as familiar as the Exxon station on the corner of County Route 523 and Route 22.

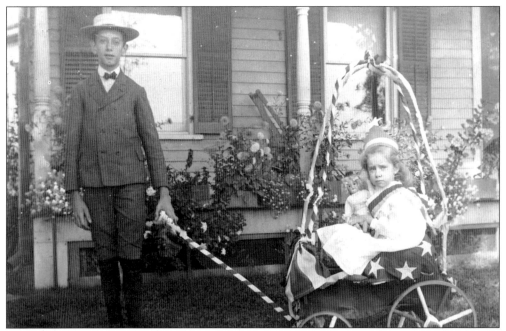

The baby parade held on September 7, 1908, was a fund-raiser to build sidewalks in Whitehouse. Here 14-year-old Elbert B. Pickell pulls his 5-year-old sister Alice LaRue (Pickell) Dilley. The wagon is dressed in crepe paper and flag decor. The photograph was taken in front of the house portion of the Pickell General Store.

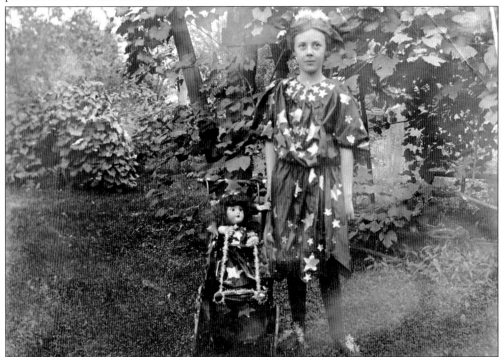

The Whitehouse parades welcomed participants from the community. Here a young lady and her doll, bedecked with stars, portray "evening" for the parade.

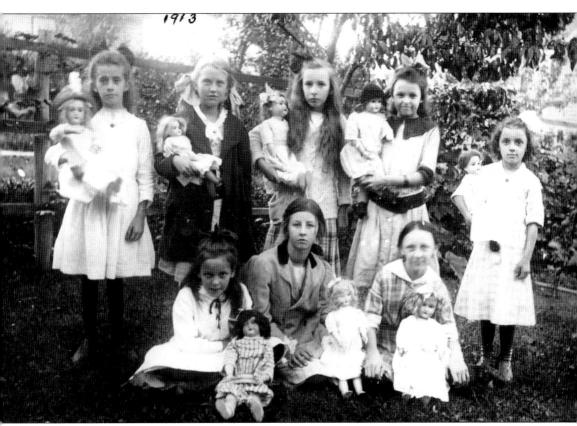

In this photograph, taken in the backyard of what is today 63 Old Highway 28, Alice LaRue stands at left in the back row with a group of young girls gathering for the Jenny Wren Doll Club in 1913. Jenny Wren dolls were the yesteryear version of today's American Girl dolls.

The Wishbone Improvement Society fair was held at the McArthur farm. The Wishbone Improvement Society, a local women's society, was responsible for purchasing the first streetlights in the community—kerosene lamps on metal posts. They also provided the funds for the conversion of the sidewalks from wooden planks to stone slabs. The local minister preached a sermon condemning all that they did because there was dancing at the fair.

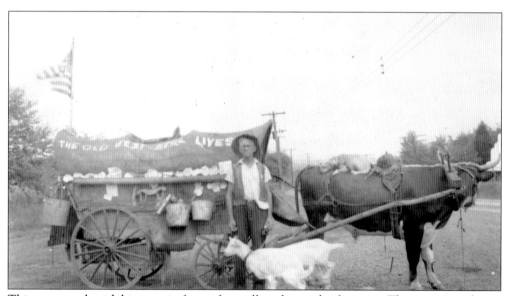

This man stands with his goats in front of a small ox-drawn chuck wagon. The wagon proclaims, "The Old West Still Lives" while a small dog takes an afternoon nap on the back of the ox.

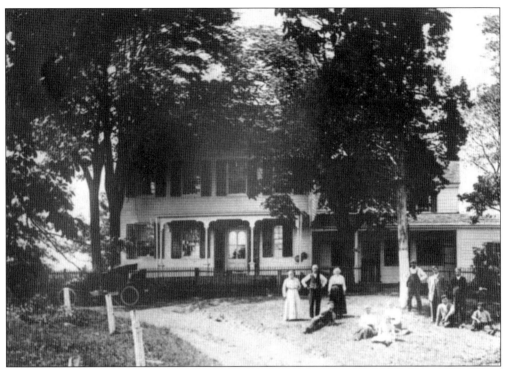

Shown here around 1910, the Jacob Klein family stands outside the Brookdale farmhouse on County Line Road. Joining them in the photograph is the family of George Stillwell, who later sold the house to William Jacqumin in 1912. The house remains a private residence today.

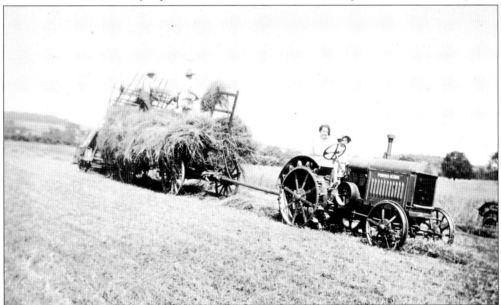

This hot summer's day in June was hay day on the Hoffman farm. Edna Space Wescott drives the tractor, while her father, Clarence Hoffman, and hired hand Russell Edgar load the wagon with freshly cut hay. The hay was then transferred from the wagon with pitchforks to create a haystack.

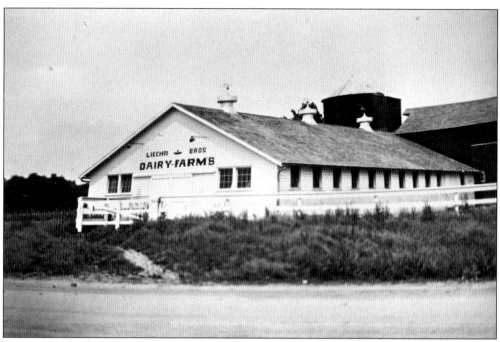

The Liechti Brothers Dairy Farms was located on the property where Merck and Company, Inc., is located today.

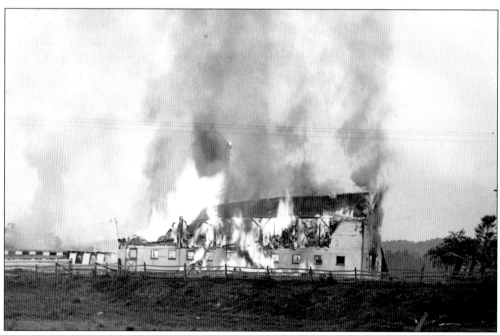

During a tragic fire on July 15, 1952, flames consumed the Liechti Dairy Farm in Whitehouse. The blaze required the assistance of both local fire companies. Seventy-five tons of hay, five tons of feed, various tools, and milking machinery were lost, bringing an estimated total loss of $50,000. The concrete silo shown in the background was damaged beyond repair.

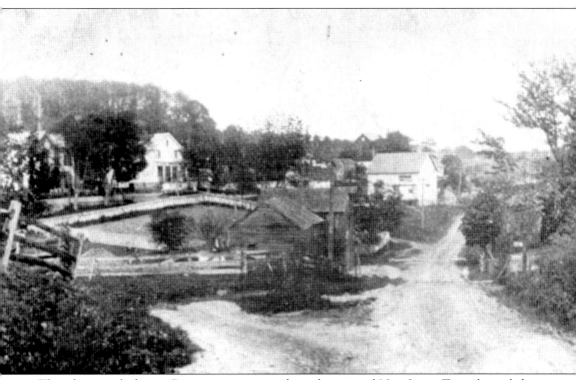

This photograph depicts Potterstown center, where the original New Jersey Turnpike and the West Jersey Society's line cross. The Bartlett Furniture Store occupied the buildings on the left. An 1851 county map depicts this collective group of buildings as a hotel. The building with the colonnaded porch and the wheelwright barn were jacked up and moved, exchanging places. The house next to that building is said to be occupied by the "gray lady" ghost. The Spinning Wheel Diner is located 20 feet higher on the right-hand side.

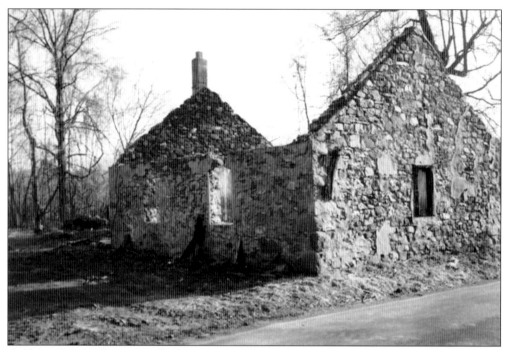

Cold Brook School was actually the second one-room district schoolhouse to serve the village of Potterstown. Built in 1828, it served as the schoolhouse during the week and as a Sunday school on Sundays. It closed as a school in 1869 when White Pigeon School was opened. Children traveled for several miles to get to the school. Later it became a private residence and was heavily damaged by fire. In 1993, the township acquired the property and the schoolhouse was restored by volunteers. Today Cold Brook School is used as a living history museum to teach area students what it was like to attend school in 1828.

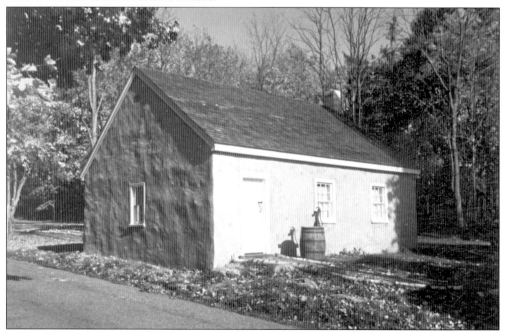

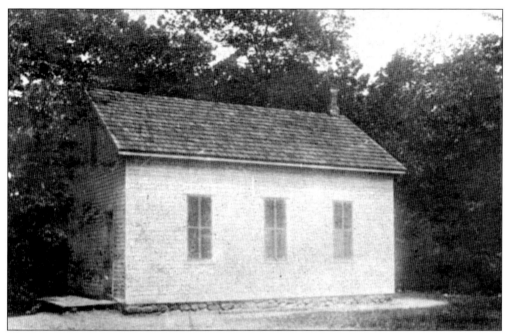

White Pigeon School, which stood on the corner of Hall's Mill and Potterstown Roads, was built in 1869 and was the successor to Cold Brook School. It is no longer standing. The school was closed about 1919 or 1920 and the children were transported by stage to the consolidated school in Whitehouse Station. Below is the class at White Pigeon School in 1914. Pictured from left to right are (first row) Russell Smith, Alvah Mannon, James Landon, Russell Landon, Louis Holland, and Harland Frost; (second row) Preston Haver, Beatrice Smith, Lizzie Smith, Florence Hall, Geraldine Hall, Dorsey Slater, and William Welsh; (third row) Floyd Todd, Lester Ramsey, Sadie Frost, Charlotte Ramsey, Ina Hildebrant (the teacher), Marion Melick, Hattie Haver, and Mabel Welsh.

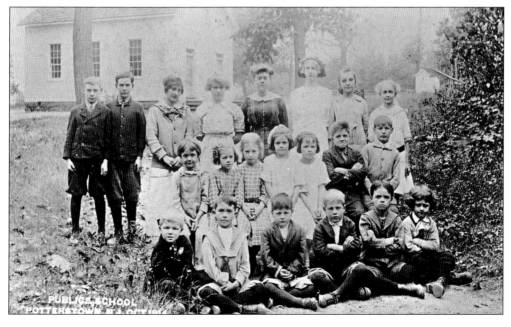

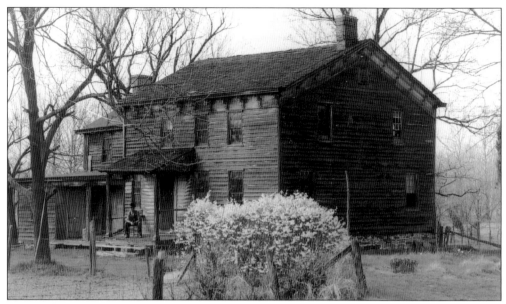

During the American Revolution, Gen. George Washington stayed in the house of Col. John Melhelm, a member of 4th Hunterdon Militia. The home was burned to the ground by vandals in the summer of 1971, thereby robbing citizens of one of the few authentically documented homes where Washington took up residence. The house's foundations can be viewed today on New Bromley Road, where a historic marker denotes the approximate location of this grand old house.

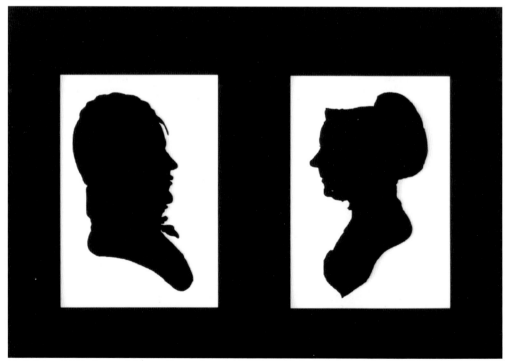

Col. John Melhelm and his wife are shown here in silhouette. The silhouette was a popular art form until the photograph took over in the 19th century.

Three

PLEASANT RUN, BARLEY SHEAF, AND DART'S MILL

The villages of Pleasant Run, Barley Sheaf, and Dart's Mill shared similar roots because all were positioned on rich, fertile lands with clean water supplies that not only sustained them but also helped them flourish.

Pleasant Run village was once fondly described as a sunny little hamlet along Campbell's Brook. Driving along County Route 629 (Pleasant Run Road) one can find many of the original farmsteads, the schoolhouse, and even the general store. These structures of yesteryear provide a glimpse of the intricate sense of community and purpose that resided in this quiet little village. John Campbell purchased the land in 1685, naming the pristine stream of water Campbell's Brook. In 1712, the Biggs, Schamp, and Cole families arrived from Long Island, New York. The highly respected Col. David Schamp, who served in secret service to Gen. George Washington during the Revolutionary War, called the village home.

Crossing Barley Sheaf bridge to head south toward the intersection of County Route 523, then known as the Whitehouse-Flemington Road, brings one to the village of Barley Sheaf. There was a general store, a post office, a blacksmith shop, a creamery, and a hotel, providing daily necessities and comforts for the village inhabitants as well as travelers. This area was once known as Farmersville, and before that Campbellsville, in honor of Catherine Campbell, who ran the hotel. Barley Sheaf remains today only as a street name with some of the old farmhouses.

Early residents of Barley Sheaf village might have driven their horses and wagons south on the Whitehouse-Flemington Road to reach Dart's Mill. Seated on the South Branch of the Raritan River was a thriving merchant center consisting of a blacksmith, a store, and a host of mills. Within the complex was a bridge that crossed the river expanse, allowing better access for the surrounding villages. Mills existed on this site as early as 1730, with the last one burning down in 1994. Some of the buildings have been restored and stand today as business office space.

Driving along the Holland Brook, one can still view this early farmstead situated on the top of the hill formerly owned by Mr. and Mrs. Abram Schomp. Michael Kinney erected the first area sawmill near this location around 1770. Logs were sawed and whiskey was distilled, and the mill yielded a profitable business for over 100 years. This farm has a New World Dutch barn found behind the white chicken coop in the center. These barns were rare and found only in the Dutch settlements along the Raritan and Hudson River valleys.

The Holland Brook winds its way through the snow-covered meadows of Holland Brook Farm just before sunrise on a cold winter morning. Majestic scenes like this one can still be enjoyed today in bucolic Readington Township.

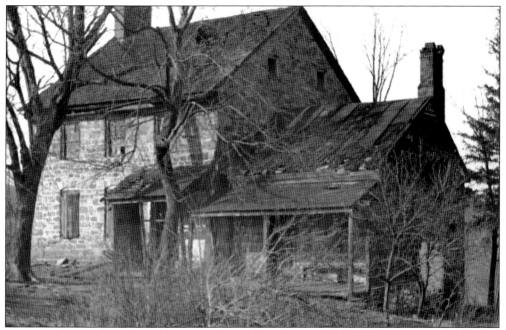

This *c.* 1709 stone farmhouse is a classic example of Georgian-style architecture from the pre-Revolutionary period. The home is situated on a hilltop overlooking Campbell's Brook, known today as Pleasant Run. The homestead stands as one of the earliest structures in the Pleasant Run village.

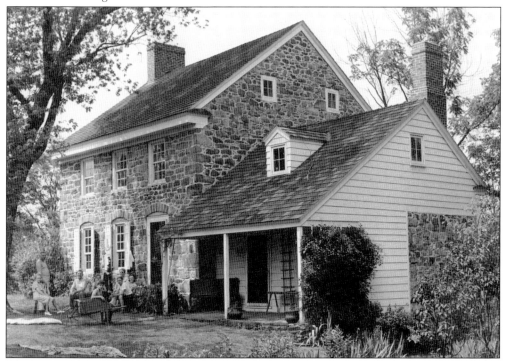

The house remains today beautifully restored, showcasing sections of the home constructed in the 1700s, 1800s, and 1900s with a newly added wing in 2000.

Mr. and Mrs. Charles E. Sutphen purchased this farm in 1908. Charles was one of the original signers of certificate of incorporation of the Dairymen's League of Readington Local.

The Ewing-Biggs homestead was a fine example of the early homes built along Campbell's Brook, known today as Pleasant Run. Located on the opposite side of the road from the Hollenback family and Sutton family homes, it was lost to the demands of the 20th century.

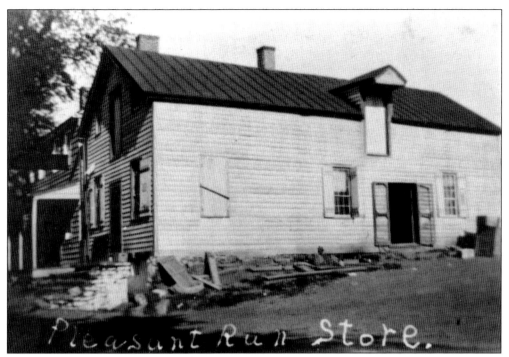

Pleasant Run Store.

Many general stores issued store credit to farmers in exchange for butter, eggs, and other produce. Isaac Thatcher clerked in the Pleasant Run store before he took it over in the 1860s. He owned it for over 20 years. When this picture was taken in 1909, the store was owned by Elijah Lane.

The old blacksmith shop was located on the Ewing-Harpence farm. At least two generations of Ewing family members ran the blacksmith shop. The building fell down in the spring of 1953.

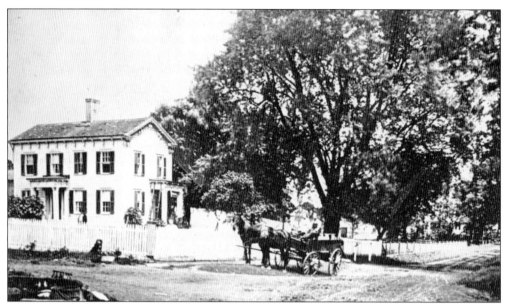

Driving west on Pleasant Run Road approaching the intersection of Cole Road, a couple drives in its wagon past the Cole family farm. A dog takes a rest at the corner and waits for the traffic to pass so he can cross the road.

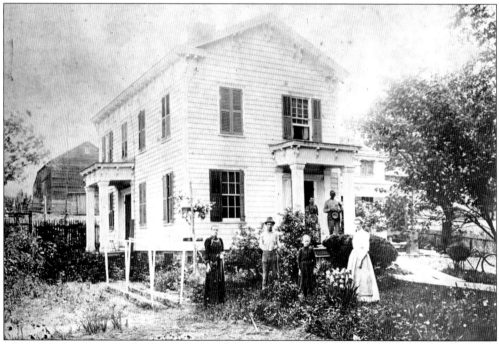

The Cole family, shown here in springtime, was one of the first prominent Dutch families to settle within the village of Pleasant Run. Their working farm consisted of approximately 110 acres, and the original barn on the hill behind the house remains today after restoration in 2001. It has been said that it was the rolling, fertile fields and the never-failing stream of pure water along this sunny hamlet that beckoned the Cole family to settle and farm this area along Campbell's Brook.

Pleasant Run School served the student population until the students of the area began to attend the consolidated school in Whitehouse Station. It still stands today on Pleasant Run Road and has been converted to a private residence.

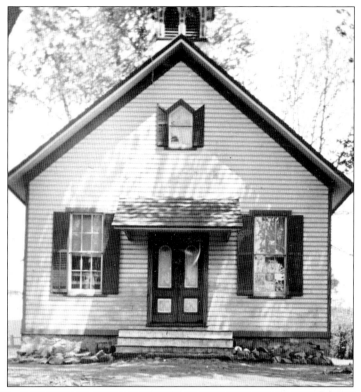

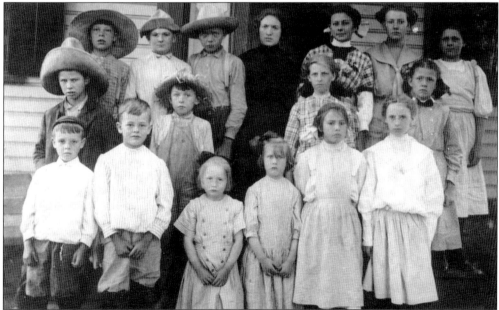

Shown here is the 1910 class photograph of Pleasant Run School. From left to right are (first row) Willard Stevens, Edgar Lane, Helen Scherck, Edna Kuhl, Almeda Kuhl, and Margaret Stevens; (second row) William Kuhl, George Cole, Sarah Emmons, and Margaret Cole; (third row) Lew Sharp, Furman Sheets, Albert Marsel, Miss Shapiro (teacher), Florence Lane, Sarah Kuhl, and Mary Sheets. Note the farm youngsters in their straw hats.

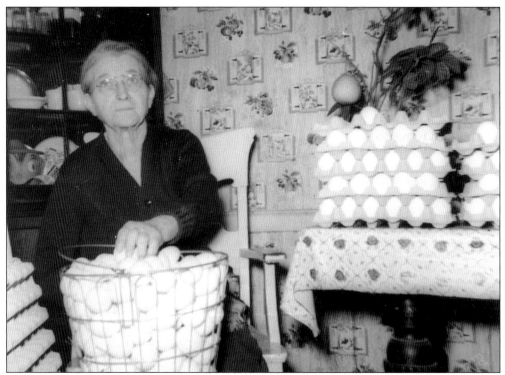

Like many other farm women, cleaning the eggs was a daily chore. After cleaning and placing them in cartons, they were transported to the egg auction in Flemington to be sold. Velma Hultz is shown here in her kitchen in 1957 preparing the eggs for market.

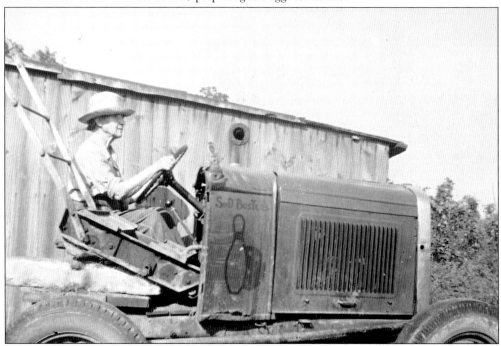

Hultz is shown here in the late 1930s driving her farm tractor.

William J. Hultz Sr. is tending to his saddleback hogs. The Hultz family owned a 100-acre farm on Barley Sheaf Road, now Summer Road. William and his wife, Velma, raised their four sons here and farmed the land well into the 1950s.

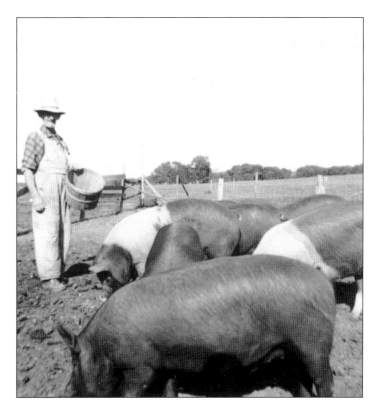

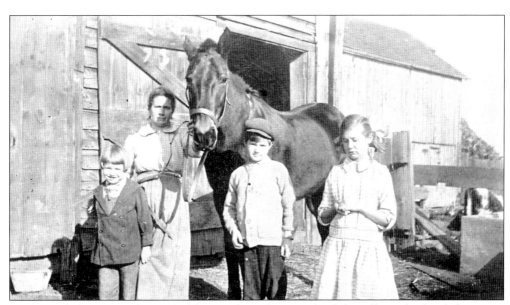

Louisa, Cal, Pierson, and Sona Kuhl pause for a photograph while walking the family horse out of the barn.

It is sale day on the Kuhl farm. Pictured here in the front yard among the many treasures for sale are Louisa Kuhl, Shirley Kuhl and her cousin Doris, and dog Rover.

Here is an early newspaper advertisement announcing a public sale at Louisa F. Kuhl's farm, located midway between Centerville and Three Bridges. The sale items mentioned are mainly farm equipment and commodities but also include an extensive list of livestock and some household items. The auctioneer presiding over the sale is Herbert Van Pelt of Readington Village. Terms of payment are solely expressed as cash.

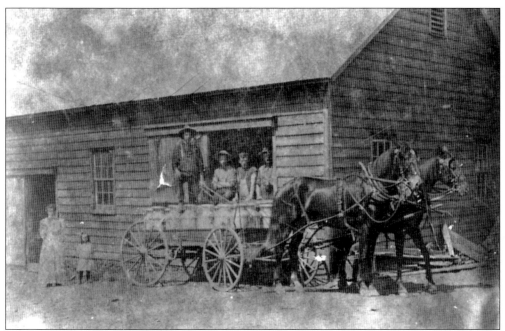

A horse-drawn wagon pulls up in front of the doors and waits to unload cans of fresh milk. The Barley Sheaf Creamery was located near the intersection of Barley Sheaf Road and the Whitehouse-Flemington Road, known today as County Route 523. Fresh milk from the local farms was brought to the creamery.

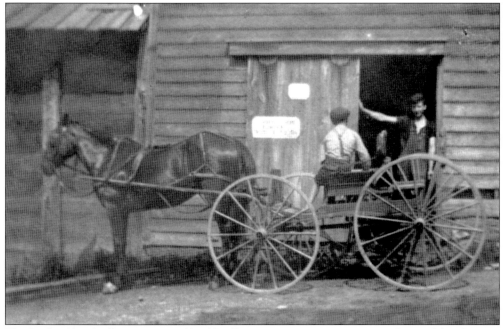

The Barley Sheaf village was a small, self-sufficient community consisting of several farmhouses, a general store and creamery, a hotel, and a blacksmith shop. All these businesses were located at the intersection of Barley Sheaf Road and the Whitehouse-Flemington Road. Alexander Kline is pictured here on his cart with his carriage horse, Ned.

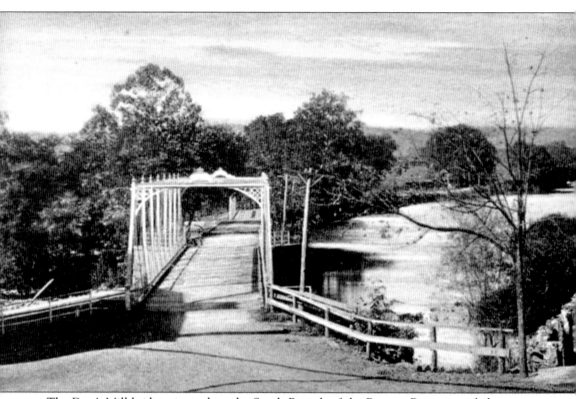

The Dart's Mill bridge, situated on the South Branch of the Raritan River, provided access to the many businesses within the Dart's Mill village. Only the bridge abutments remain today. The mill consisted of a merchant's center, a blacksmith, a store, and a complex of various mills. Some of the mills dated back as early as 1730, and the last remaining mill burned down in 1994. Only remnants of the bridge remain visible today.

Four

STANTON AND DREAHOOK

A village has existed at the base of Round Mountain since the first Dutch settlers came to the area in the 17th century, attracted by the beautiful countryside and farmland. The village was first called Mount Pleasant, later Housel's, and then Waggoner's Hill. Finally the name was changed to Stanton in 1849. Some thought it might have been named in honor of Pres. Abraham Lincoln's secretary of war, Edwin M. Stanton, but it was actually named after William Penn's land agent, who owned land in the area and a home in Philadelphia that he called Stenton.

A school was established in Stanton in 1780 when a small building on a triangular plot of ground was erected in the forest. When William Housel died 20 years later, he left $200 to be applied to the education of the poor children of the neighborhood. This school was then known as Housel's Free School.

The Dutch Reformed Church and the general store came to the village in the 1830s. The church was established by families who had been accustomed to attending divine worship at Readington, but the distance made it inconvenient and burdensome. This led them to make an effort to provide a more convenient place of worship for themselves. The store, like others of its time, provided household and agricultural necessities for the residents.

Dreahook comes from the Dutch word for triangle. It was possibly named for the convergence of the roads to Whitehouse, Flemington, Readington, and Pleasant Run, where the families of Wyckoff, Voorhees, Van Devanter, Kline, Krug, Emery, and others settled to farm the rich soil near Round Mountain. The hamlet boasted a blacksmith shop, a school, and a store.

The Stanton Reformed Church and the Stanton General Store still dominate the village at the crest of the hill on County Route 629, but the hamlet of Dreahook has mostly disappeared, being supplanted by housing developments and the rerouted County Route 523 and County Route 620.

STANTON

READINGTON TWP.
Scale 20 Rods to the inch

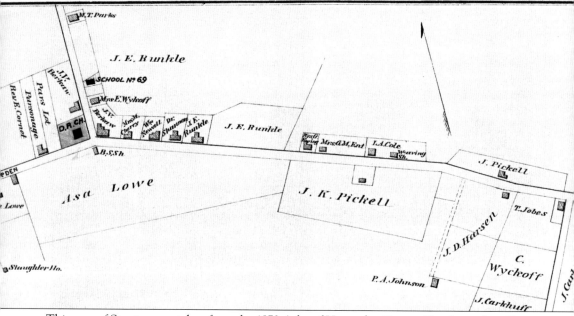

This map of Stanton was taken from the 1873 *Atlas of Hunterdon County New Jersey from Recent and Actual Surveys and Records under the Superintendence of F. W. Beers*, Comstock and Cline, 36 Vesey Street, New York.

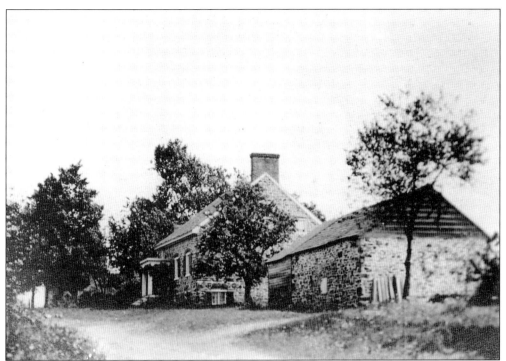

Hillcrest Farm, a German-style bank house on Stanton Road, was built around 1741. The Levi Mettler Cole family purchased the house in 1894. Aletta Ann Dalley Cole "took in boarders" to finance the installation of new dormer windows, which let in more light. When the Wayman family purchased the house in 1933, the dormers were immediately removed as they were not felt to be authentic to the period of the home. This house, like all Colonial houses during this period, faces south.

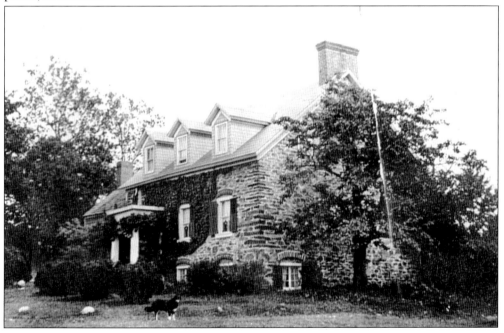

This house, known as the J. V. Berkaw house, served as the second Stanton storekeeper's house. Its bracketed roof, symmetrical windows, and charming portico indicate it was built around 1830 when Stanton was forming as a village. During the 1830s, the area was called Mount Pleasant.

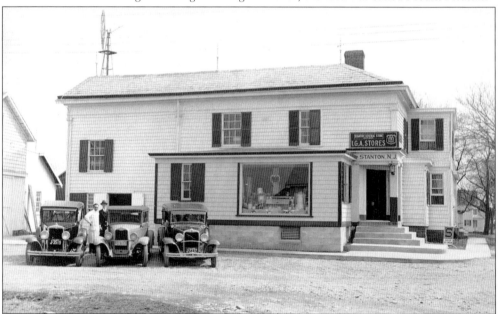

The Stanton General Store, established in 1837, was an IGA market owned by Raymond and Bessie Wilson when this photograph was taken during the late 1920s or early 1930s. During this time, an addition containing a storefront window was built, and the horse's hitching posts were removed to accommodate cars. The Stanton General Store is still in operation today.

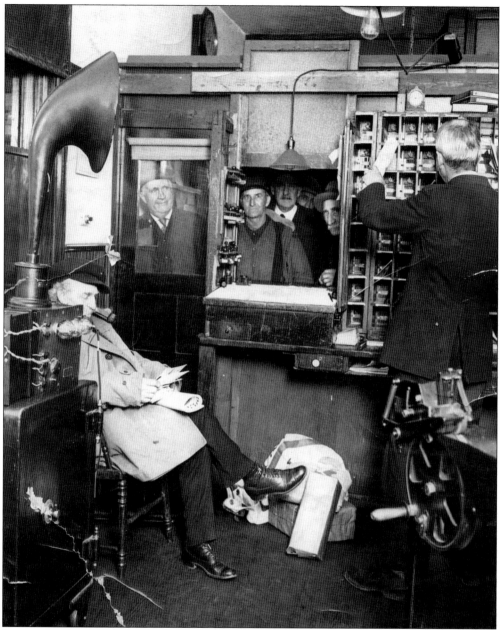

Stanton was called Mount Pleasant until it opened a post office. In the days before zip codes, no two towns in a county could have the same name. Consequently, Mount Pleasant became Stanton.

A classic vernacular-style I house, shown here nestled off the road, provided all the necessary comforts to the Smith family of Stanton.

Anne Sharp LaRue Smith is seen here in 1917 sitting on a bench peeling apples outside her Stanton home. The window next to her has a piece of cheesecloth pinned around it. This was commonly done on the windows of the food storage room. Coverings of this kind allowed air circulation, which kept the produce fresh while keeping the bugs out.

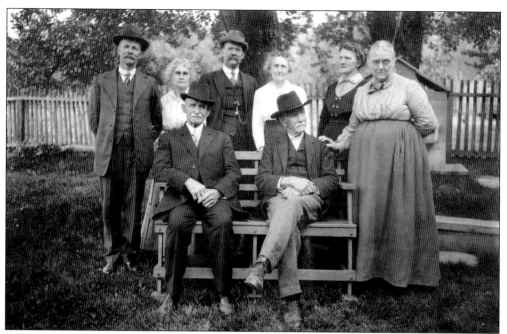

Around 1917, members of the Smith family pose for a portrait in the backyard of their homestead located in Stanton. The men standing in the back are Frank L. Smith (left) and George B. Smith. Anne is standing to the right of the bench. The man sitting on the right side of the bench is John M. Smith.

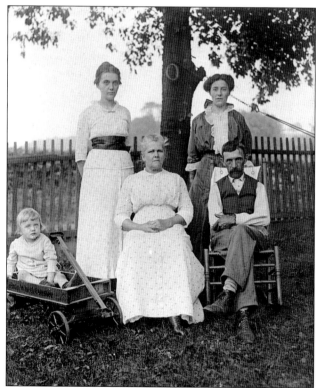

Members of the Sheets family pose at their home in Stanton around 1915. Family members in the photograph are, from left to right, Lawrence I. Sheets, Susie Sheets, Ann Frances Smith, Betty Ruth (a cousin of Lewis), and Lewis C. Sheets.

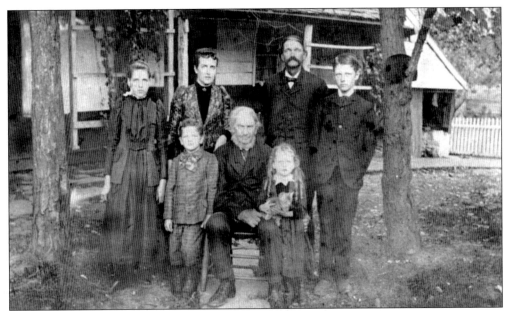

The Cole family is shown in front of their home on Pleasant Run in 1893. The family members are, from left to right, (first row) Levi Kline Cole, Holloway Cole (brother of Levi Mettler Cole), and Catherine Carkhuff Cole (age 5); (second row) Laura Rebecca Cole, mother Aletta Ann Dalley Cole, father Levi Mettler Cole, and John Benjamin Cole. The Carkhuffs, Klines, Coles, and Dalleys were all early Dutch families.

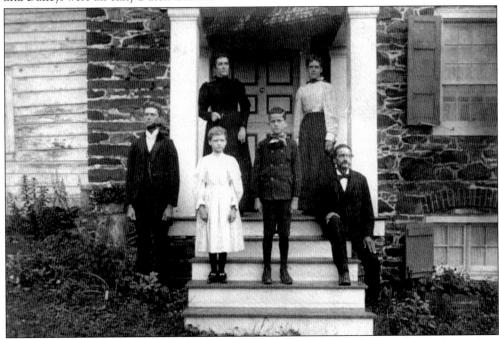

The Cole family is shown at their new home, Hillcrest Farm, around 1897. Pictured are, from left to right, (first row) John, Catherine, Levi Kline, and father Levi Mettler; (second row) mother Aletta and Laura. The house was built by William Housel and was directly across from Stanton Reformed Church.

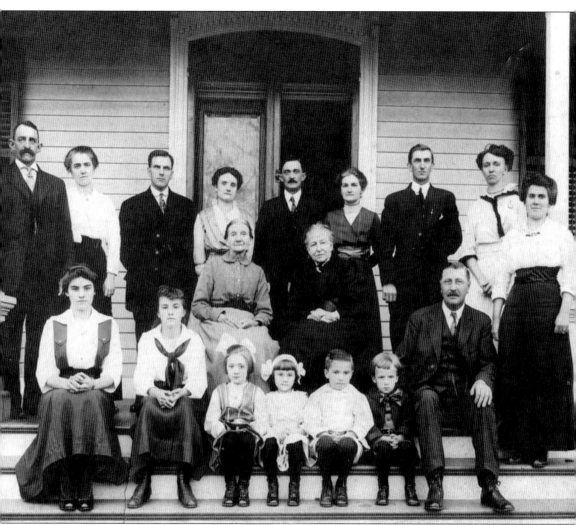

The Hoffman family is gathered for Thanksgiving in Stanton. The members of the family are, from left to right, (first row) Jessie Bartles, Florence Bomberger, Edna Hoffman Space Westcott, Mabel Hoffman Miller, George Stothoff, John Huff Jr., Samuel Stothoff, and Bessie Stothoff; (second row) Chris Bosenbury and Mrs. Stothoff; (third row) John and Mary Hoffman Van Doren, John and Elizabeth Hoffman, John and Sara Hoffman Huff, and Clarence and Stella Hoffman. The Hoffmans settled on the South Branch of the Raritan River in 1740. The family has continued to farm the same land, which is known today as the Bartles farm and is the oldest continuous family farm in the state.

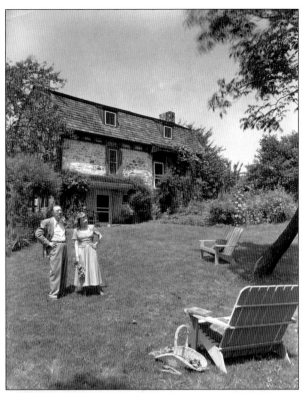

Howard Lindsay, a Broadway producer, purchased this 1741 stone Dutch bank house in 1935 as a weekend retreat for his wife, Broadway actress Dorothy Stickney, and himself. They are shown on the lawn outside the house. Many famous Broadway actors and producers spent weekends at this home. After the last performance of the week, Stickney, Lindsay, and invited guests piled into a limousine for the trip to Stanton, sipping martinis along the way. After Lindsay's death, Stickney held Friday night potluck suppers for neighbors at the house, and the grounds were illuminated with her collection of fairy lights.

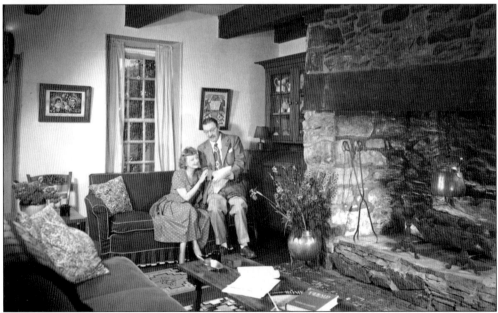

Stickney and Lindsay are shown studying a script in their living room. Lindsay died in 1968, but Stickney continued to use the house as a retreat into her 90s. Readington Township purchased the house and surrounding 68 acres from her in 1997 with Green Acres funding, and today it is one of the town's three museums, known as the Bouman-Stickney Farmstead, named for its first and last owners. The house has been restored to its original 1741 look.

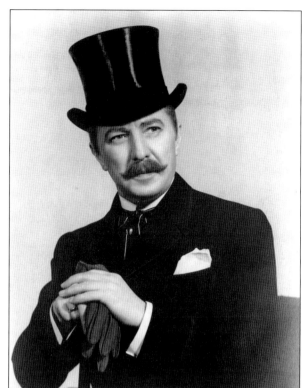

Here are some glamour shots of Lindsay and Stickney, costumed for their starring roles in the Broadway play *Life with Father*, which Lindsay wrote. The play opened on Broadway in 1940, and for her role, Stickney won the Barter Award for best performance of the year in 1940. The award was presented to her by Eleanor Roosevelt.

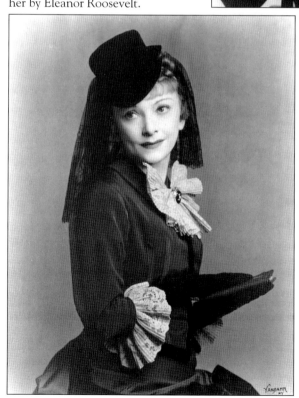

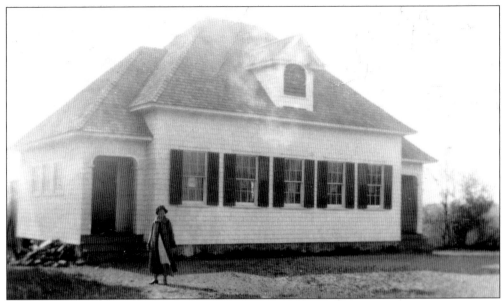

Stanton School, built in 1848 and 1849, was the one-room schoolhouse that served the village of Stanton. The schoolteacher, Caroline Bushfield, is standing in front. The schoolhouse had separate entrances for boys and girls. Stanton School was preceded by Housel's Free School, built in 1802 through a bequest from William Housel. The school was to be for the poor children of the district, especially those from "good Christian parents."

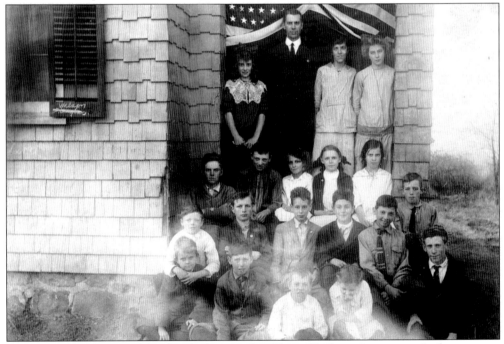

The students at Stanton School with their teacher, Harry Hoff, are shown outside the entrance to the boys' coatroom. Among those attending were Carrie Ewing, Josiah Cole, Irene Hall, Margaret McPherson, Cornelius Turner, and Jack Bloys. They were farm children who walked miles to attend the one-room schoolhouse.

for the benefit of
**STANTON RECREATIONAL
AREA**

December 5, 1970
1–5 p.m.
Donation $2.50

Started in 1961, the Stanton Holly Trail is an annual holiday event where historic homes in and around Readington are opened to the public for tours. Selected homes are adorned with traditional decorations for the season, and the proceeds of the event are shared between Stanton Reformed Church and Hunterdon Medical Center.

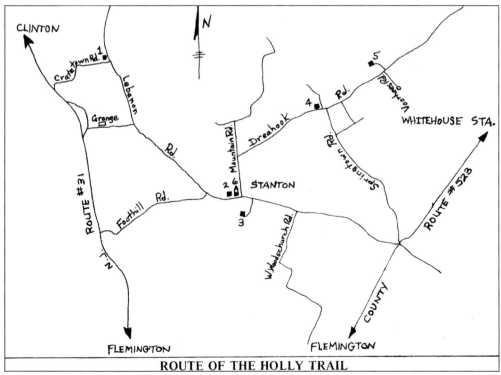

ROUTE OF THE HOLLY TRAIL

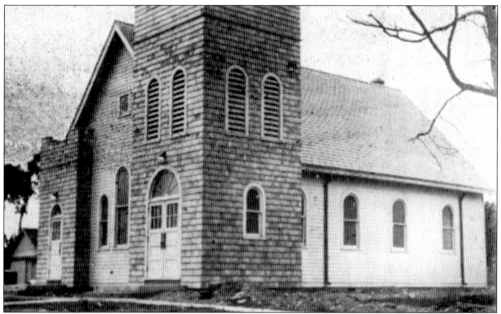

The Stanton Reformed Church was incorporated in 1835 as the Reformed Dutch Church at Mount Pleasant. The congregation was made up of congregants from the Readington Dutch Reformed Church who felt that is was too far to travel to Readington Village. Land was purchased for $30 from Benjamin and Abraham Anderson for the church building. In 1931, lightning struck the church and it was destroyed by fire.

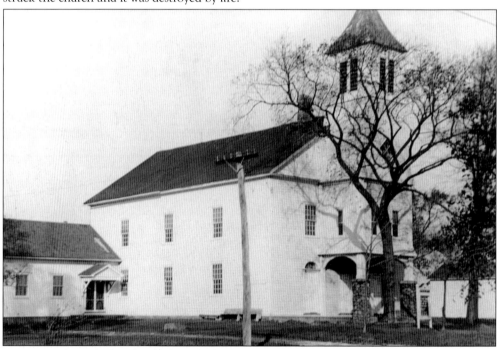

Stanton Reformed Church rebuilt after the fire. The people banded together and raised enough money to build a new sanctuary, fully paid for on its first day of dedication in 1932. Further additions were made to the structure in 1964 and 1965.

Heading south toward Flemington was tough along the Trenton-Butzville Road in 1916. The State of New Jersey took over the road as an unnumbered highway in 1924. In 1927, the state named it Route 30 then named it Route 69 until the signs all disappeared. It then became Route 31. The Readington Township portion of the road has four lanes and improvements continue to be made.

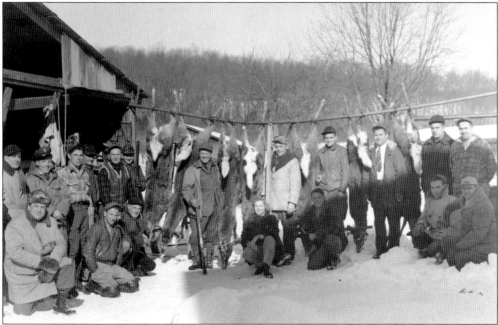

Shown here are the Readington men and one woman who participated in the last deer hunt held in Round Valley. The kneeling man second from the right is Carlton Durling. Others shown include Walter Miller and Fred Hurter. Shortly after this hunt, the valley began filling with the 55 million gallons of water that became what is known today as Round Valley Reservoir.

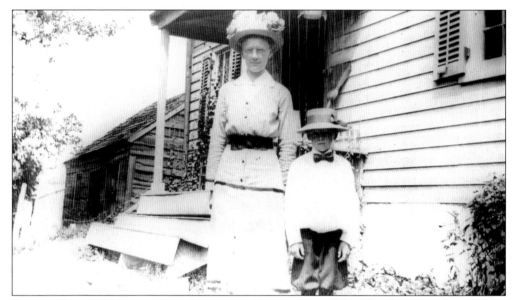

Georgia Turner and her son Cornelius are standing in front of their farmhouse in their Sunday best on the Turner farm around 1920. A close look shows the green bean vines growing up strings carefully tied to both sides of the porch.

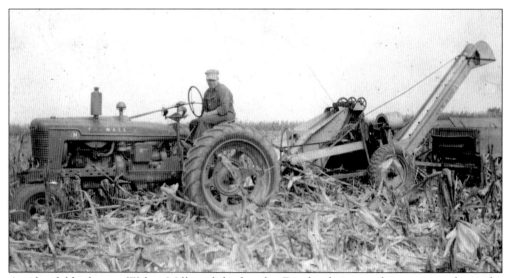

Amid a field of corn, Walter Miller of the hamlet Dreahook is seen here cutting down the last of a summer corn crop. Miller was a descendant of the Cole family, one of the original Dutch families.

The Force farm is located on Holland Brook Road. Today the road has been widened up to the front door. Holland Brook Road has changed very little from its appearance on the Erskine map of 1778–1779. Robert Erskine was George Washington's mapmaker. He mapped the "remarkable" roads of the day.

This is a rear view of the Force farm in 1936. Currently Holland Brook Road divides the house and barns pictured in this vista.

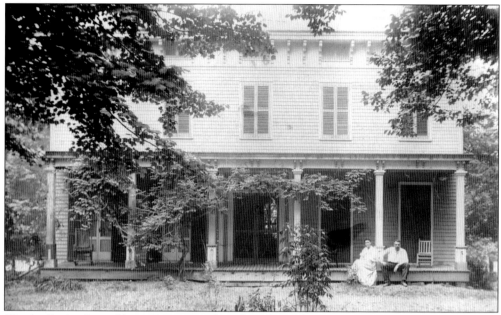

Charles Engler Sr. and his wife are seated on the edge of their porch in 1912. The Engler family homestead was located on Old Mountain Road, known today as Dreahook Road. Engler owned a lumber and millwork business in Jersey City and moved out to the country for health reasons. Years ago, this was known as the Bohlander farm and was located on the original 300 acres belonging to Martin Wyckoff around 1750.

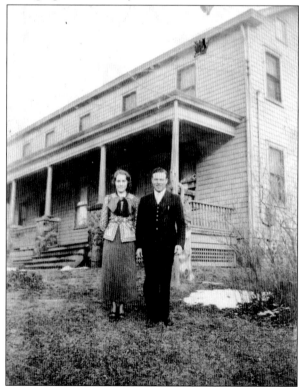

Mabel (Hoffman) and Walter Miller, parents of a current Readington resident, are shown standing in front of the Miller-Bertrand farmhouse in the hamlet of Dreahook, an early Dutch settlement. The house was built by Nicholas Wyckoff around 1813 and today is a private residence.

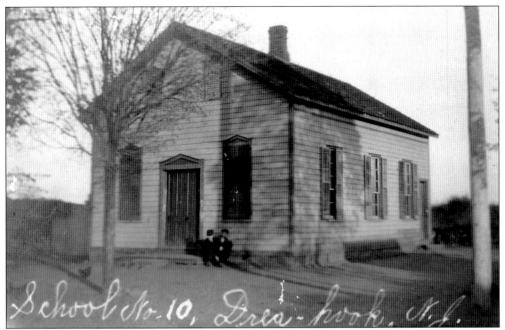

Dreahook School was located in Dreahook village on what is currently known as County Route 523 and East Dreahook Road. Dreahook is the Dutch word for triangle, and the school was also referred to as the "Three Corners School." Reportedly this was the third schoolhouse in Dreahook.

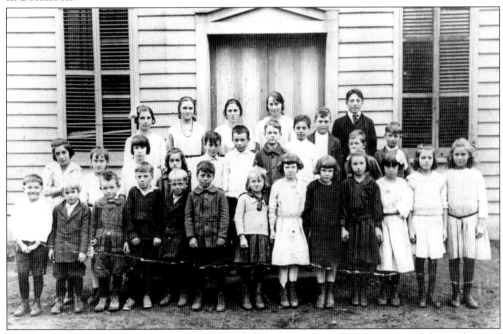

Students are gathered in front of the Dreahook School in 1922. The age range of the students in these one-room schoolhouses can be clearly seen in this picture. Several members of the Wade family, a farm family living on Readington Road, were members of this class. The school burned in 1932.

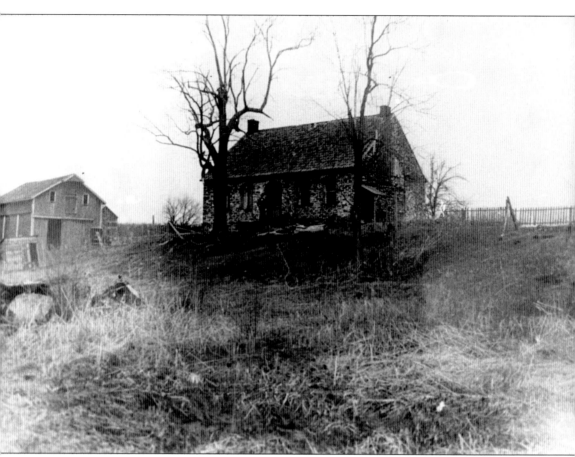

The Pickell family homestead in Readington was built between 1735 and 1740. Baltus Pickell was one of Readington's first settlers, coming to America from the Palatinate around 1710. The house, which was located on Mountain Road, was razed in 1915. Pickell built the first German Lutheran church in New Jersey, located in Potterstown on land donated by Aray Van Guinea, a free black man.

Five

THREE BRIDGES
AND CENTERVILLE

Centerville village sprang up along Campbell's Brook near the tavern on Old York Road, through which the profitable Swift Sure Stage line ran from New York to Philadelphia. The tavern was the midpoint of the long journey, thus giving the village its name. As long as Old York Road was the primary thoroughfare for horses and wagons, Centerville thrived. The village boasted a school, a store, a post office, a church, and a blacksmith shop.

The Vlerebone and Hoagland farms were situated about two miles south of Centerville on Old York Road where the South Branch of the Raritan River was crossed by three bridges. The neighboring farms' owners, John Vlerebone and Harriet Foster Kline, sold some of their land to the Central Railroad of New Jersey to erect its South Branch line. After the railroad line came through in 1864, Vlerebone and Kline subdivided parcels of their land fronting Old York Road into building lots, giving birth to the village of Three Bridges.

The homes and businesses of Three Bridges continued to prosper and grow, and in 1875, the Lehigh Valley Railroad became Three Bridges' second railroad. By 1880, up to 14 passenger trains and numerous local freights stopped in Three Bridges, and the village became a major shipping point for agricultural products.

Just as the stage gave way to the railroad, cars and trucks supplanted the train. The South Branch and the Lehigh Valley lines no longer stop in Three Bridges, and most retail shops along Main Street are gone. Nevertheless, the community still comes together at events held at the local firehouse and the church located on Main Street.

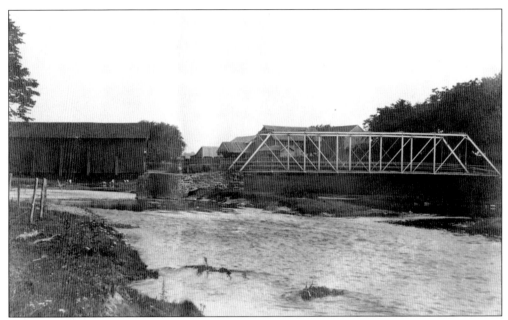

The eponymous three bridges over the South Branch of the Raritan River did not exist in 1769 when the area was called Sebring's Ford. The first bridge was built during the second half of the 18th century, and a second bridge was added in 1801. Changing river currents necessitated a third in 1813. The name Three Bridges remains even though the third bridge was eventually rendered unnecessary and the two bridges shown above became one in 1970.

This view of Main Street in the village of Three Bridges was captured around 1910. At that time, Main Street was a dirt road, and the drainage ditches alongside the road were for runoff and household dirty water.

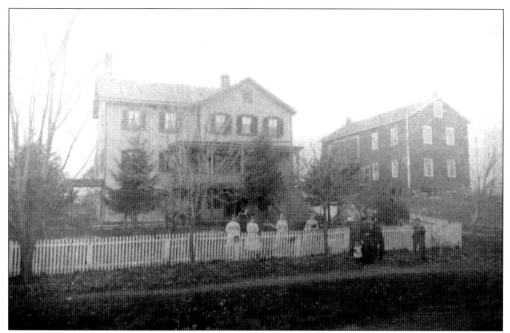

Rodney Wilcox's house, also known as the Chamberlain house, shown here on the left, was located on Main Street a few doors away from Hipple's Garage. The building to the right was built in 1890 and used at various times as a print shop and a hatchery until it burned in 1936. It then became the site of Harold Cain's grocery store and finally the village's post office.

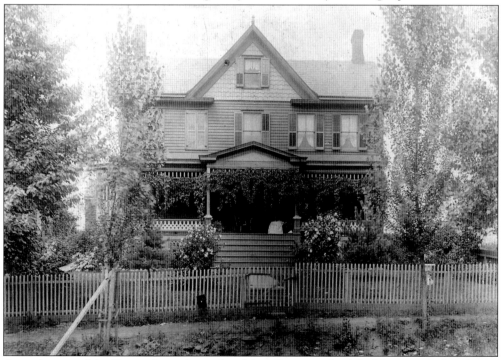

An early view of the Kinney house located on Main Street south of the library was taken during the 1890s. The house was owned for years by the Hart family.

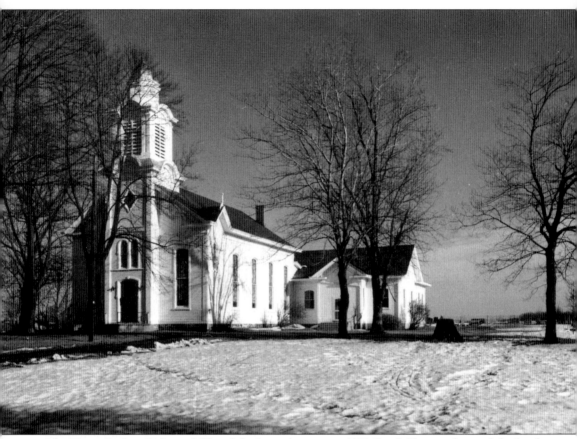

The Three Bridges Reformed Church had a rocky start in 1873. Jacob Higgins donated the land but shortly thereafter sold his farm to James Brokaw, who offered a different parcel. Before the church's completion in 1874, local carpenter William Van Fleet was killed in a fall from the roof. The church was finally dedicated in January 1875. This photograph was taken by Frank Kuhl early on a winter morning in 1961.

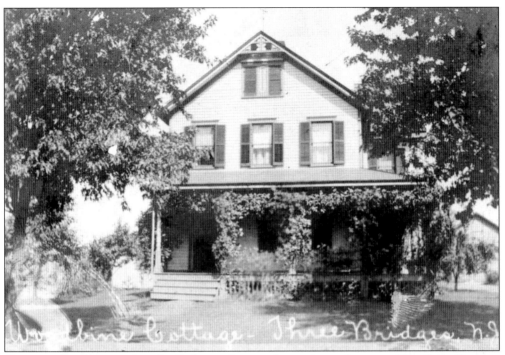

Shown in this photograph is the Probasco-Sergeant house, better known as Woodbine Cottage. This home was located on Railroad Avenue in Three Bridges.

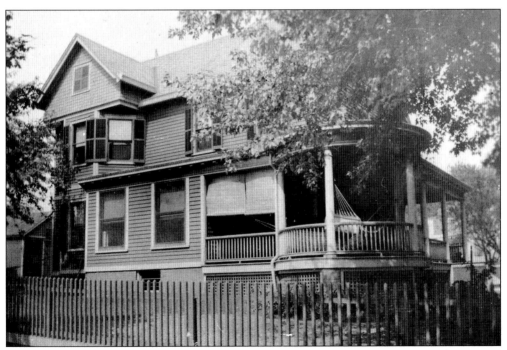

A hammock on the front porch in the shade of a tree is a perfect place to while away a summer afternoon. The Kuhl family lived in this Queen Anne house from 1946 to 1962. It was built by C. H. Wood, who owned a coal yard and hay press in the late 19th century.

George Dalley operated the wheelwright and blacksmith shop in Three Bridges during the early 1900s. Howard Kelenbenz was his apprentice.

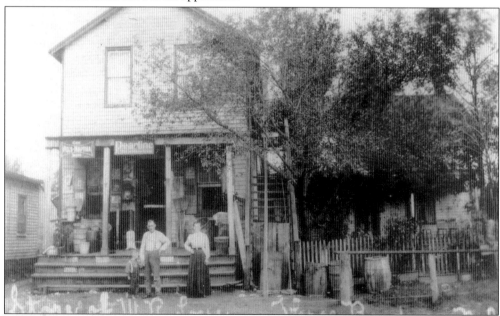

General stores did more than provide the community with household and farm needs. They also served as gathering places for townspeople and farmers. In 1885, William Love opened his store, which provided an upstairs room for meetings, church dinners, and other entertainment. The store was continued by the Kinney family but burned to the ground in 1916 and was never rebuilt.

Readington Township was the home of several creameries, many located near a railroad line. The first creamery in Three Bridges was operated by Squire Hill and was located across from Joseph R. Dilts's store. The creamery had facilities to keep the milk cans cool until they could be loaded onto the daily milk train and shipped to larger markets.

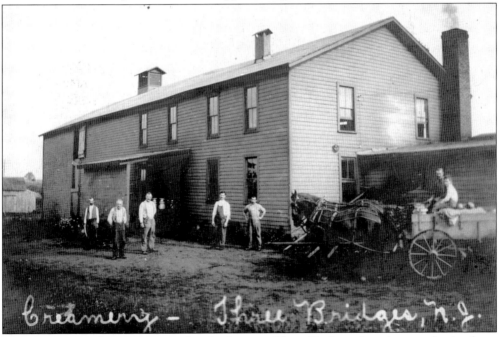

The creamery in this picture was the third one in Three Bridges, the other two having been destroyed by fire, one of which may have been arson. This creamery too was destroyed by fire in 1927 and was replaced with a concrete building.

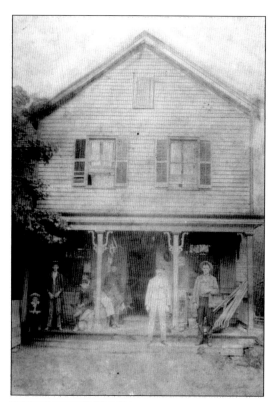

The first general store in Three Bridges opened shortly after the railroad came through in 1864. It served the town until it was destroyed by fire in 1899. The store was replaced by the large, two-story structure of Joseph R. Dilts, which still stands today.

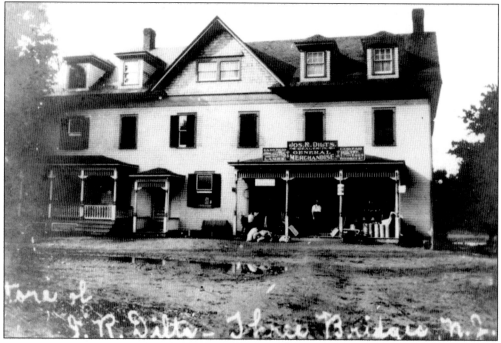

This pre-1937 view of Main Street in the village of Three Bridges looks south toward the South Branch of the Raritan River. In the background is the Sheets family's general store.

In the late 19th century, Frank Van Syckle opened a butcher shop across from the Lehigh Valley Railroad station. The sign on the shop's left pillar reads "oysters," which were packed in dry ice and brought into town by rail. The building was originally a single-story structure. The second floor was a later addition.

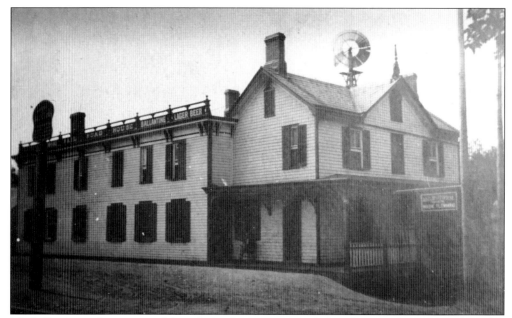

Mark Fleming, who emigrated from Ireland in 1872, owned the Three Bridges Hotel when this photograph was taken before Prohibition. During Prohibition, the hotel gained notoriety as being the first in the county to be padlocked by authorities after residents testified to seeing drunken and disorderly persons coming from the premises. Owner John Filmon, who asserted that residents were prejudiced against him, received a three-month jail term. The hotel poured its last drink in the early 21st century, when its license was transferred to Whitehouse.

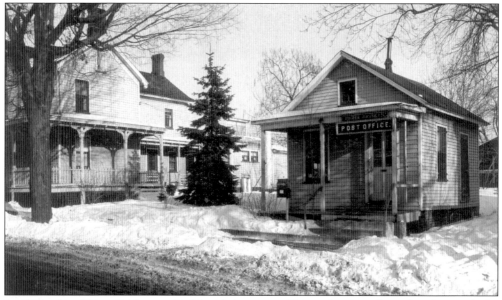

In 1866, when Three Bridges applied for its own post office at the time the railroad arrived, the city elders had to decide on a name for the village. George Vlerebone suggested Boney Station, possibly after himself. However, Judge Joseph Thompson ruled, "No, it has always gone by the name of Three Bridges and it always shall." The tiny building shown in this photograph was one of the several buildings that served as the post office at one time or another.

John Hipple ran Hipple's Garage in Three Bridges. Here he is shown on the left next to his new 1950 Packard sedan. Burroughs Dilts is on the right. The garage, located just north of the Lehigh Valley Railroad, was originally built by George Dilts and still operates as a garage.

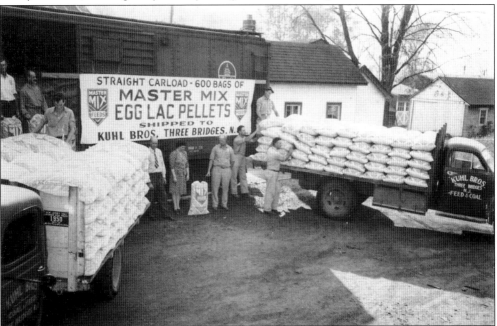

This photograph appeared in the June 20, 1947, edition of the *Hunterdon County Democrat* newspaper. The banner hanging from the train car announces that 600 bags of Master Mix egg lac pellets had been sold to Kuhl Brothers Feed and Coal in Three Bridges. The Kuhl Brothers trucks are backed up to the train car getting loaded with product. From left to right are Russell Kuhl, John Wieland in the train car, Hiram Kemper on the truck, Cal Kuhl, Ms. Moore (later Kuhl), William Kuhl, Pierson Kuhl on the ground, Levi Porter on the truck, and Fred Porter on the ground.

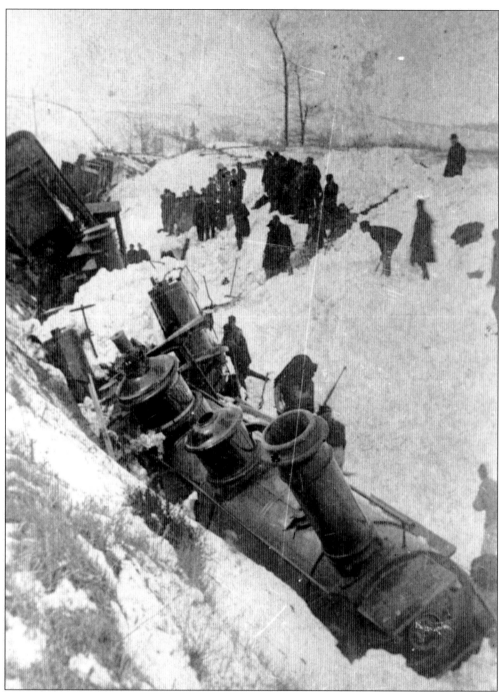

The blizzard of 1888 caused havoc throughout the eastern United States. This photograph depicts a Lehigh Valley Railroad construction train that derailed when it hit a 20-foot snowdrift near Three Bridges, killing three engineers and severely injuring one. The wreck also verified the reliability of the train telegraph, which enabled communication directly from the moving train. The surviving engineer was able to telegraph for help although wires were buried under the heavy snow.

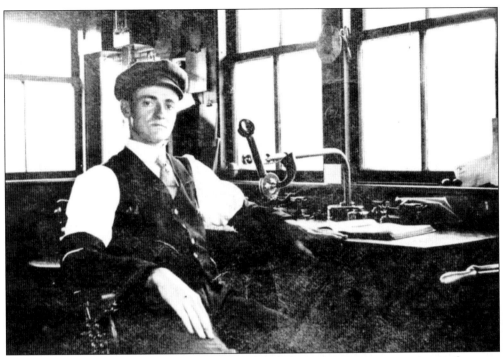

The telegraph was of vital importance to the railroads for maintaining communication between the railroad and the train. The telegrapher dispatched train orders and messages to the train crews and reported the train's location to the dispatcher. Consequently the railroad station was the place to go to find out the latest news. This early-20th-century photograph shows Three Bridges station manager George Kaelenbenz at his trusty telegraph key.

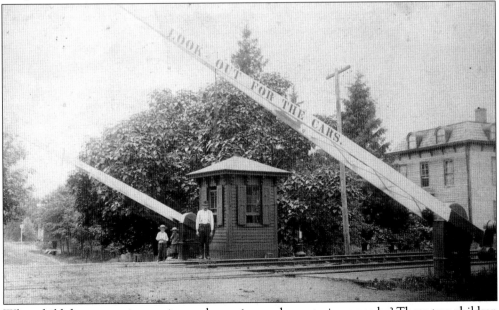

What child does not enjoy waving at the engineer when a train passes by? These two children wait with the gate tender in Three Bridges for a Lehigh Valley Railroad train to pass. The house on the right was built in 1866 and housed the railroad section foreman.

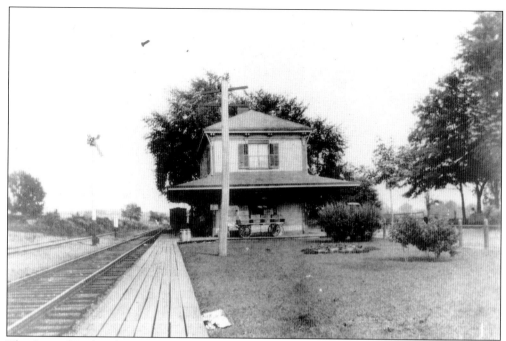

The Central Railroad of New Jersey built this Three Bridges station in 1864 when it established its South Branch line from Somerville to Flemington. The branch operated until 1953, and this station was demolished in 1955.

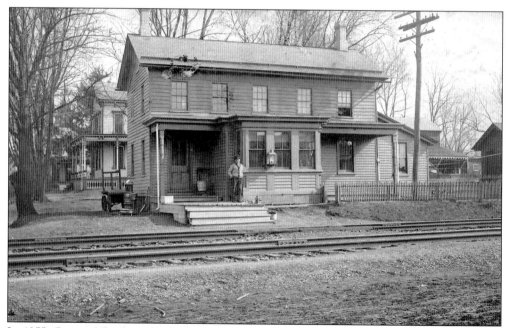

In 1855, George Vlerebone built the first house in Three Bridges that was not part of a farm. Twenty years later, the Easton and Amboy Railroad Company, a subsidiary of the Lehigh Valley Railroad, bought the property and used the house as its Three Bridges station. John Hipple bought it in 1963, and Albert Fischer used it for his lawn mower sales and repair shop.

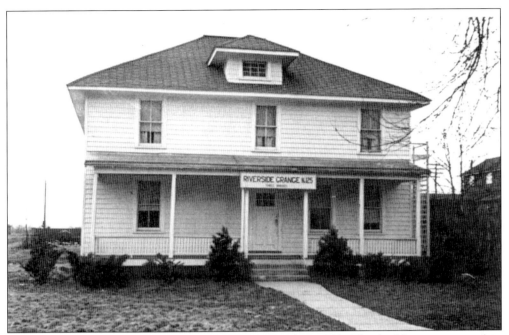

The Riverside Grange in Three Bridges was organized in 1900. This building was erected in 1902 and widened in 1918. Sheds in the rear warehoused cooperatively purchased farm supplies. The Grange hall was the site of the May 20, 1927, meeting to organize a group of volunteers who would serve as a fire company to protect the community.

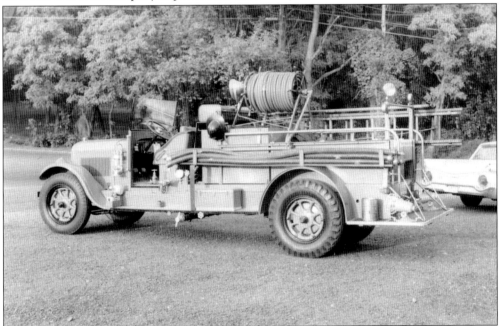

The first Three Bridges fire truck, a 1927 Reo chemical engine built by Foamite Childs, was purchased in April 1928 for $3,750. The original engine was converted to a water pumper and retired in 1947. The truck was later sold to the Green Knoll Fire Company, where it was restored and photographed during the early 1960s.

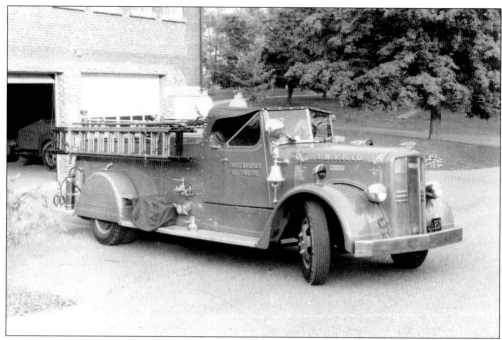

This 1949 Ford 800-gallon tanker was purchased in 1952 by the Three Bridges Volunteer Fire Company. It was converted to haul water instead of gasoline to fight fires in rural areas of the township.

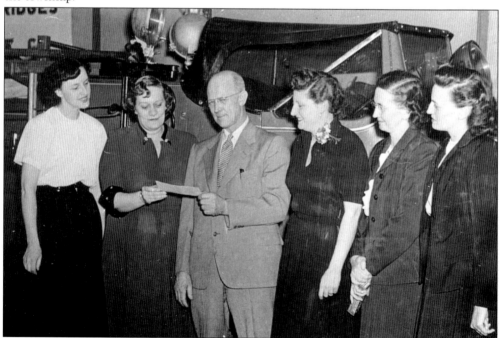

In April 1953, members of the Ladies Auxiliary donated $120 to William Kuhl, secretary of the Three Bridges Volunteer Fire Company. From left to right are Joyce Symansky, Irma Kuhl, Mrs. George Hall, Thelma Miller, and Mrs. Raymond White. The ladies earned the money by winning the game show *Strike It Rich*.

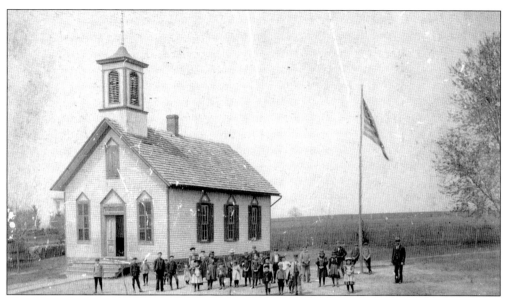

This Three Bridges schoolhouse was in operation from 1872 to 1909. It replaced the schoolhouse at Van Fleet's Corner, which was built in 1840 on the same site as an earlier schoolhouse constructed before 1813. The schoolhouse in this photograph stood on Main Street on the site of the current firehouse. In 1909, the schoolhouse was purchased by William Griffith and moved one block north, where it remains today, with modifications, as a private dwelling.

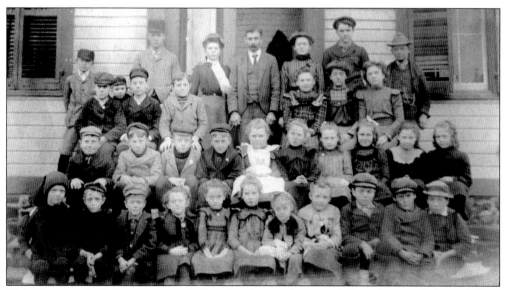

This photograph depicts a group of Three Bridges students, including Spencer Dilts, and their teacher posing outside the schoolhouse. It was not uncommon for 30 students, ranging in age from 5 to 18, to attend the schoolhouse.

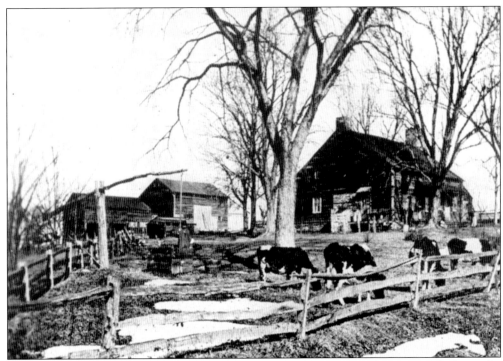

The Porter farm was located in Three Bridges. This photograph, taken in 1905, shows the original clapboard farmhouse with cows grazing in the front pasture.

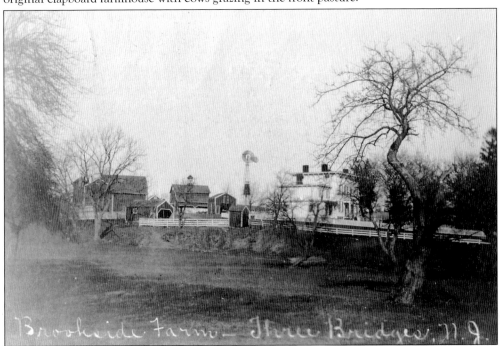

Brookside Farm — Three Bridges N. J.

Brookside Farm was once a prosperous farm along Old York Road. Although the farmland was sold decades ago to make way for a gas station and a funeral home, the magnificent Italianate house still presides at the northern edge of Three Bridges.

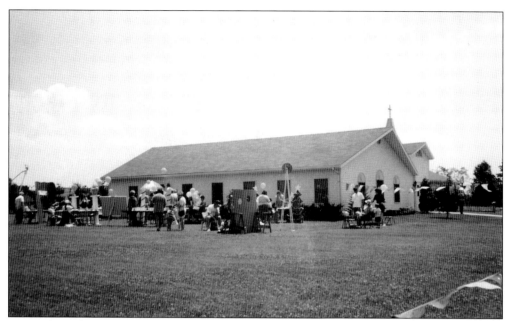

Hunterdon Christian Church held its first worship service on April 8, 1979, in the firehouse at Whitehouse Station, with 35 people in attendance. In 1982, the process of acquiring a church of its own began with the purchase of land on Summer Road followed by the design and construction of the building over the next few years. The picture above shows a youth celebration on the lawn of the completed church.

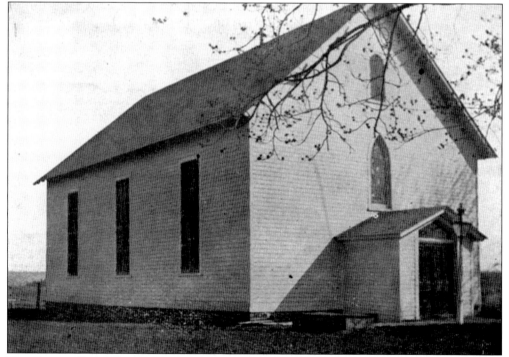

The Centerville Methodist Episcopal Church was founded in 1870 and built in the same year. The building originally had two front doors.

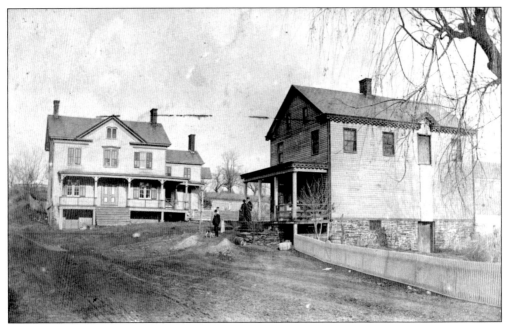

The village of Centerville is located north of Three Bridges by Campbell's Brook on Old York Road. The village, which was established in the early 18th century, is named because of its location at the center, or halfway, point on the Swift Sure Stage route between New York and Philadelphia. The building on the right is the store, while the other structure is located on land that housed the original pre-Revolutionary Centerville Hotel.

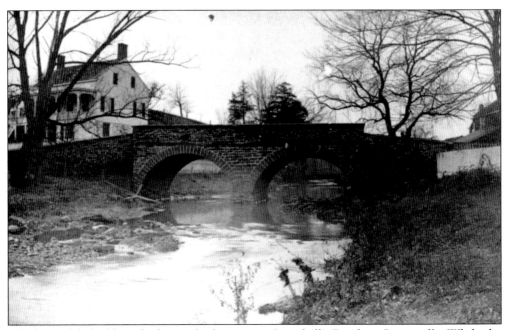

This beautiful, double-arched stone bridge crosses Campbell's Brook at Centerville. While the house still stands, the bridge has been replaced.

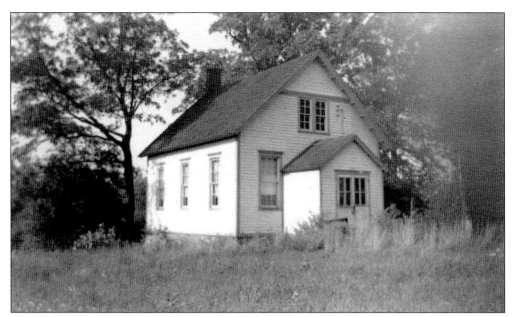

Centerville School, built in 1851, was redone in 1875. Two schoolhouses preceded this building, but their locations are unknown. The Readington Museum's Eversole-Hall House was given an exact replica of this one-room schoolhouse by its last teacher.

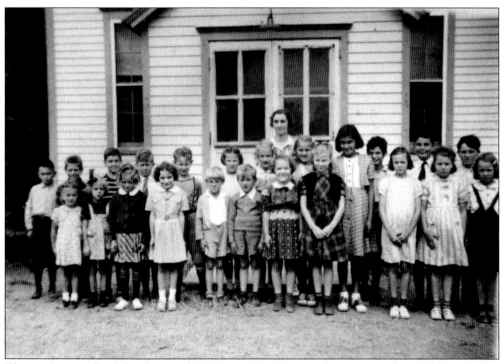

This is Centerville School around 1939 or 1940. Among those pictured are Wilma Simon, Jean Hall, Marjorie Case, Doris Kline, Ruth Porter, Betty Brokaw, Ed Becker, Harold Hopf, Ray Brokaw, Harold Van Fleet, Laura Hart, Anna Herddor, Susan Thompson, Venice P., Leon Lipschitz, and Mayer Saloman.

Centerville School provided for all its students' needs.

This view from about 1905 of Walter Kanach's farm on Lazy Brook Road in Three Bridges reflects the simplicity of farm life in scenic Readington. The pastures enclosed by split-rail fence and one-lane bridges on the dirt road harken a time that seems to have passed by.

Six

WHITEHOUSE STATION

In 1849, when the Central Railroad of New Jersey established its Whitehouse train station about one mile south of Whitehouse Village, growth concentrated in this area, where business owners could have easy access to the goods shipped by the railroad. The Union Hotel opened up shortly after the railroad arrived to accommodate the passengers on the new iron horse. Mrs. E. A. Kline started a milliner's shop "at the depot" in 1852. In 1870, Isaiah Voorhees established a drugstore where he sold his "Prize" Poultry Powder, "Boss" Horse and Cattle Powder, Magic Cough Syrup, Voorhees' Liver Pills, and Voorhees' Tooth Ache Drops. He also dispensed prescribed medications. A. C. Durling began his successful dairy business, and general stores, such as those owned by W. T. Hoffman and John B. Davis, provided staple items, fancy groceries, and dry goods. By the mid-19th century, Whitehouse Station had become the township's main municipality, possessing "more enterprise to the square inch than perhaps any other town of its size in the state."

Already established Readington families, such as the Fields and the Pidcocks, opened additional businesses in this new village, but newcomers were attracted here as well. The prospect of owning a small farm beckoned Polish immigrants from urban areas. They brought their devout Catholic faith with them, and Our Lady of Lourdes, the township's first Catholic church, was established to serve the community along with the Dutch Reformed Church.

Although Whitehouse Station's Main Street is now paved and residents may shop at malls along major highways, it still houses many unique shops and restaurants. In addition, one can still catch a train to Newark in Whitehouse Station.

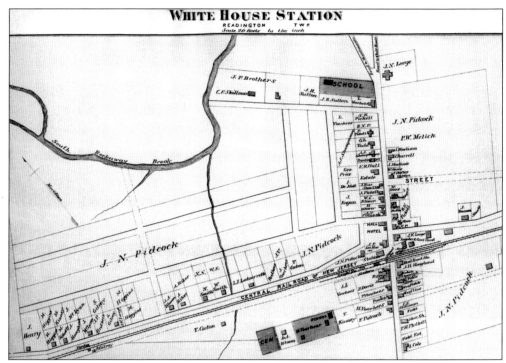

This map of Whitehouse Station was taken from the 1873 *Atlas of Hunterdon County New Jersey from Recent and Actual Surveys and Records under the Superintendence of F. W. Beers*, Comstock and Cline, 36 Vesey Street, New York.

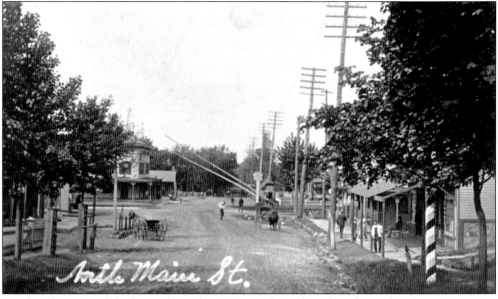

Besides the painted barber pole and towering telegraph poles, the railroad crossing gates spanning the road are prominent in this 19th-century view of Main Street looking north. The manually operated gates were raised and lowered only at one end. After a fatal accident in 1946, the Hunterdon County grand jury requested that automatic gates be installed at Whitehouse Station. These were the first automatic gates on the Central Railroad of New Jersey.

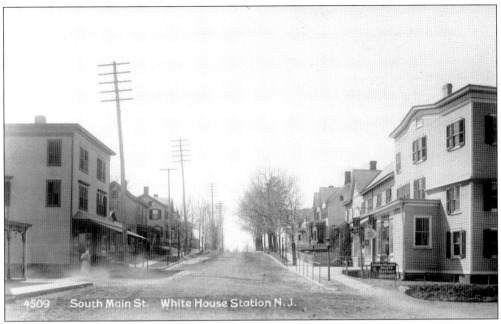

Voorhees' Drug Store, shown here on the right in this southward-facing view of Whitehouse Station, was stocked with a fine line of fresh drugs and chemicals. Voorhees manned the prescription counter and accurately dispensed them at all hours.

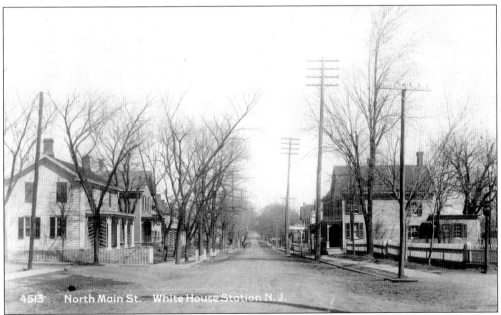

Not much has changed since this late-19th-century photograph looking north at the intersection of Railroad Avenue and Main Street was taken. The Whitehouse-Flemington Road was partially paved in 1919, with one lane down the middle. After the railroad came through around 1845, the area grew quickly and businesses sprang up. Although early on it was referred to as White House, it eventually was called Whitehouse Station.

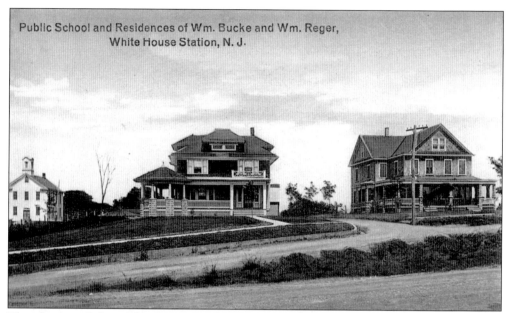

Public School and Residences of Wm. Bucke and Wm. Reger,
White House Station, N. J.

This photograph shows Main Street in Whitehouse Station, north of the village. The Whitehouse Station schoolhouse can be seen on the left side of the photograph, the residence of William Bucke is in the center, and the residence of William Reger is on the right. All three structures can be seen today behind mature landscape.

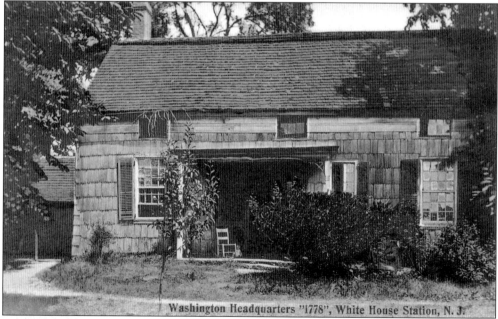

Washington Headquarters "1778", White House Station, N. J.

Abraham Van Horne erected this house around 1757. Note the irregularly spaced, multipaned windows indicative of Colonial structures. This house is of Dutch construction with a gambrel roof and large fireplace chimneys. It is located at the end of Washington Drive near the South Branch of the Rockaway Creek. On this land, Van Horne had a mill and tavern along with farm outbuildings. His tavern had white walls and was referred to as "the White House," a name that stuck.

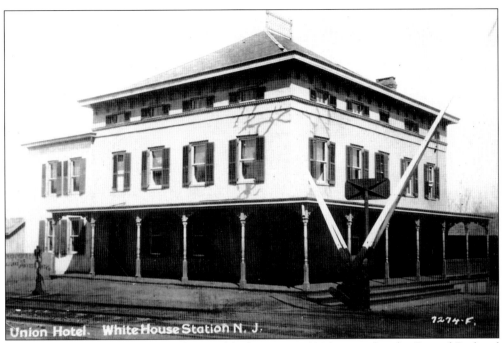

Whitehouse Station's Union Hotel opened for business in 1846, soon after the Central Railroad of New Jersey came to the village. In 1891, it was owned by L. P. Wooden and was known for its comfortably furnished rooms and its dining room offering the best the markets could afford.

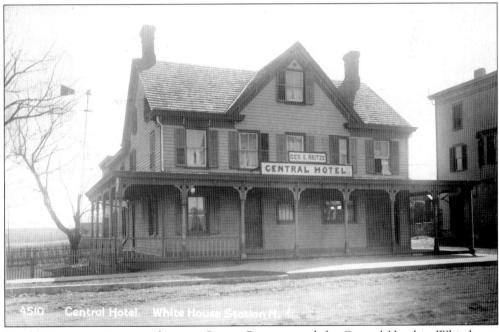

In addition to owning a candy store, George Reitze owned the Central Hotel in Whitehouse Station in the early 1900s. Called "the trainman's hotel," it served as a place to stay for the men who worked on the trains. It was demolished sometime in the 1980s, and the site is currently a parking lot.

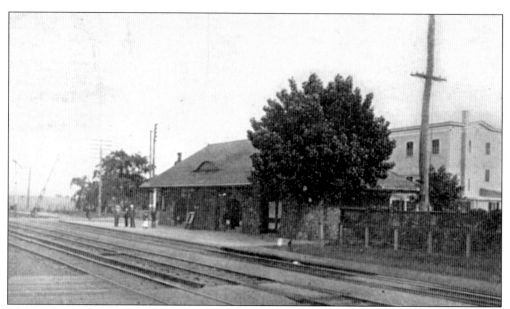

This Central Railroad of New Jersey station in Whitehouse Station was built in 1892 and designed by renowned New York architect Bradford Gilbert. Gilbert was the consulting architect to 18 principal railroads in America. As the need for local railroad stations declined in the second half of the 20th century, the building fell into disrepair. In 1980, Readington Township leased the building and volunteers restored it to its earlier grandeur for use as the village's library. The building was added to the National Register of Historic Places in 1984.

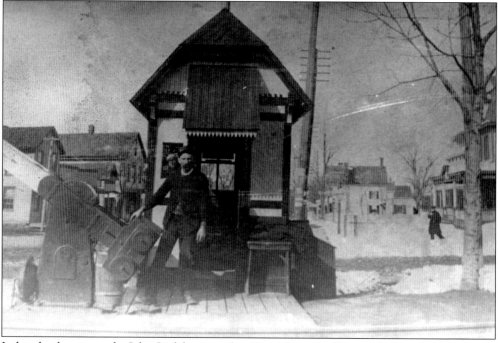

In his shack, gate tender Jake Opdyke was a familiar sight at the Central Railroad of New Jersey crossing in Whitehouse Station. When a train was coming, a bell rang in the shack. As the train approached, he lowered the gates and stopped traffic.

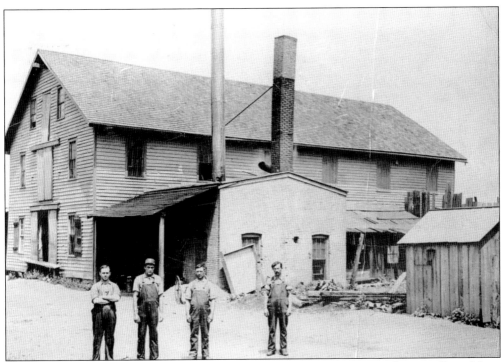

Augustus C. Durling founded the Durling Creamery in the 1890s. Here milk was collected from surrounding villages and shipped to Newark, Elizabeth, and New York City on the Central Railroad of New Jersey.

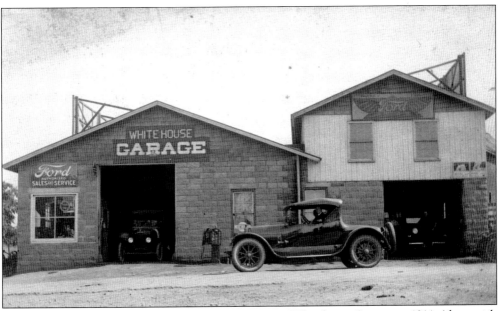

Arthur E. Burdette owned the White House Garage in Whitehouse Station in 1914. Along with selling Model Ts, he also sold farm equipment.

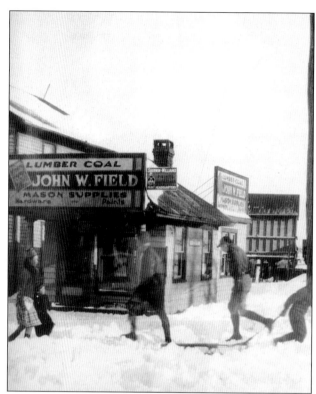

Young people tramp through the snow past John Field's lumberyard in Whitehouse Station located on Main Street. The lumberyard and the homestead were demolished and replaced by a gas station.

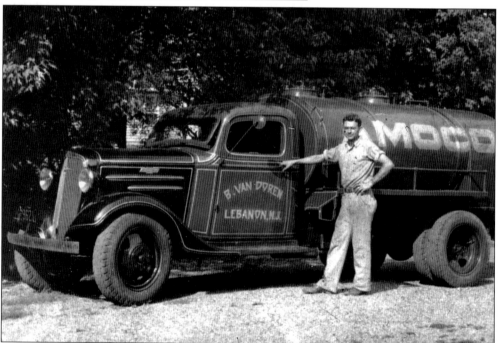

Ben Van Doren started an oil business in 1939. The Van Doren family still owns the business that services customers throughout central New Jersey. In this 1939 photograph, Van Doren proudly shows off his first truck, a 1936 Chevrolet.

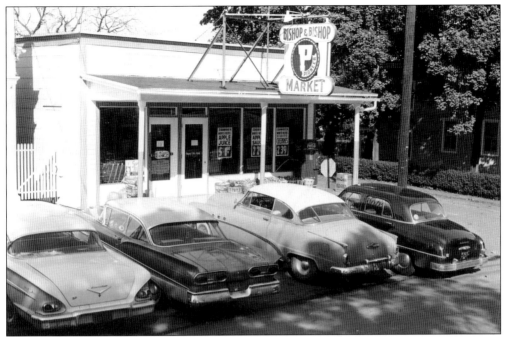

Shown in this 1950s photograph, the original Bishop's Market was in the center of Whitehouse Station. In 1979, Bishop's moved its store to a shopping center on Highway 22. The original store in town has since been home to several businesses and is currently a beauty salon.

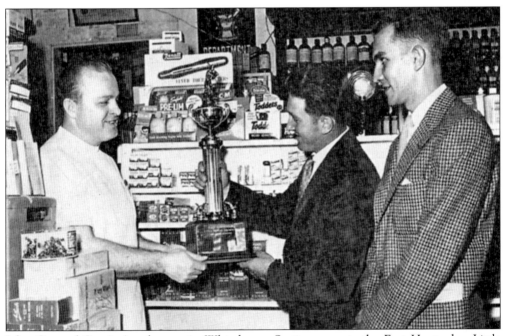

John Gray of Gray's Apothecary in Whitehouse Station accepts the East Hunterdon Little League trophy from Bucky Lance (center) and Floyd Prall. His sponsored team, the Rexallites, won the championship in October 1955. "Doc" Gray's kindness to those in need was evident in the many prescriptions that left the store unpaid for.

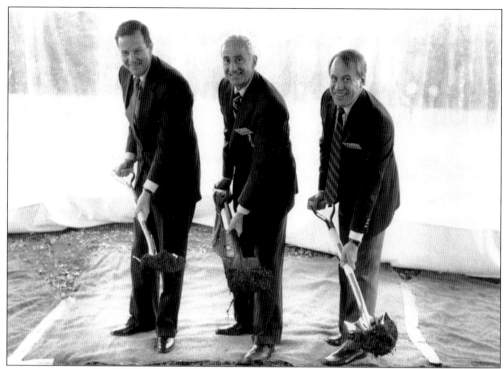

Dignitaries break ground in 1989 for the construction of the Merck world headquarters in Whitehouse Station. From left to right are New Jersey governor Thomas Kean, Merck chief executive officer Dr. Roy Vagelos, and Readington Township mayor Jeffry H. Tindall.

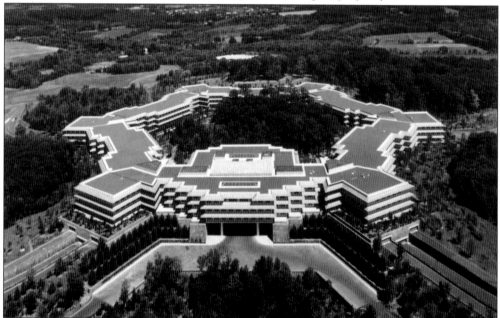

Merck and Company, Inc., the global pharmaceutical giant, made Whitehouse Station its world headquarters in 1992. This aerial photograph shows its distinctive hexagonally shaped facility designed by well-known architect Kevin Roche.

The Royal Blue Coach operated in the 1930s. Its home was next to the Union Hotel on Main Street in Whitehouse Station and stands today as the Station Auto Repair. The coach brought passengers from Whitehouse, Mechanicsville, Potterstown, Stanton, and other outlying villages to the bustling center of the village and the train station.

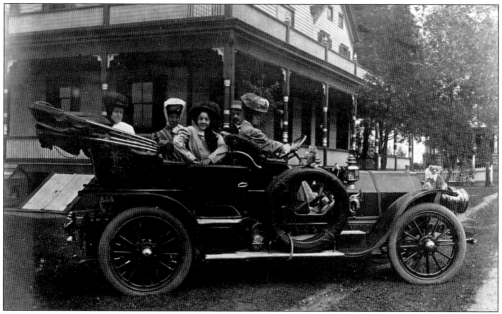

Members of the Pidcock family start out on a drive from their Whitehouse Station home. James N. Pidcock engaged in civil engineering and agricultural pursuits and was a dealer in livestock before entering politics. He served in the New Jersey Senate from 1877 to 1880 and the U.S. House of Representatives from 1885 to 1889. Later he was one of the founders of the Rockaway Valley Railroad.

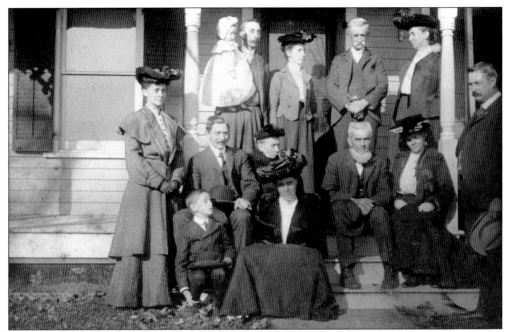

Prominent landowners in the early days of Readington, the Pickell family gathers for this photograph on the front porch of the their house and store on Main Street in the village of Whitehouse Station around 1904. Seated among various Pickell relatives and friends is the bearded Baltus Pickell, the patriarch of this family. To the right of Baltus is his second wife, Alice. Standing on the porch in the back row (far left) are John Lambert Pickell, holding his daughter Alice, and his wife, Ella Green Pickell. The young Alice later married into the Dilley family and continued to live in this home until as late as 1975.

Hiram Allegar and Baltus Pickell (right), members of two prominent Whitehouse farming families, stand with an unidentified woman.

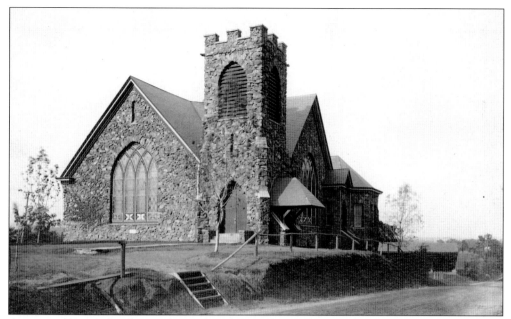

A group of Dutch families, realizing that the Readington Dutch Reformed Church was a great distance away, decided to start a Dutch Reformed church closer to their community. They built their first church in 1808 and their second in 1850. This is the third Rockaway Reformed Church, which was built in 1899 of local stone. The site of the first two buildings was on Old Highway in front of Rural Hill Cemetery.

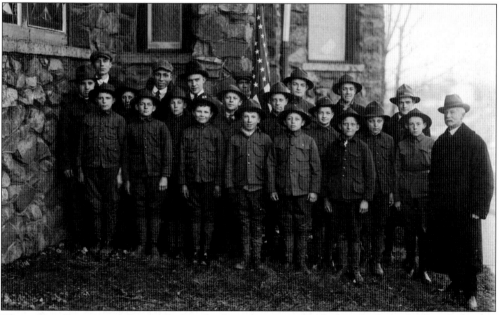

These Boy Scouts stand proudly beside the impressive Rockaway Reformed Church in this World War I–era photograph. The present church, located at the entrance to town, was built in 1899. The stone for the church came from stone hedges in the Stanton Mountains and was built by farmers clearing their land. Augustus C. Durling organized local farmers to donate, load, and haul the stone to the building site at no cost to the church.

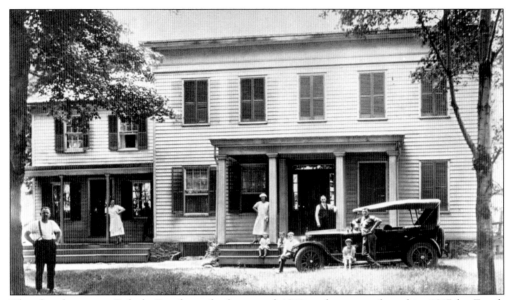

This farmhouse on Pulaski Road was built around 1810 and was purchased in 1917 by Frank and Nellie Borowiec and their family, who were some of the many Polish immigrants to settle in Whitehouse Station. The Borowiec family opened their home to members of the Polish community, and their living room became the first home of the Polish American club. The light fixtures in the living room were brought from Poland, and many polka parties and social events were held here. During the Depression, the Borowiecs were forced to rent out part of their house to the family pictured on the right.

On September 17, 1982, Pres. Ronald Reagan came to the Polish American Citizens Club, and the oath of allegiance was administered to candidates for American citizenship. Pictured on the left of Reagan is Gov. Thomas Kean, and on the right in the black robe is Judge Clarkson Fisher, the chief judge of the U.S. District Court of New Jersey, who administered the oath.

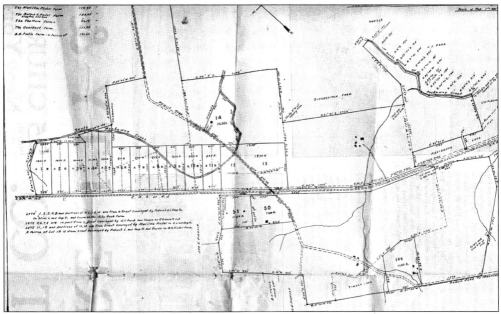

Even in the early part of the 20th century, development pressure on Readington Township was intense. Starting in 1912, Kline Realty and Improvement Company, a New York City–based developer, bought contiguous farmland in Whitehouse Station, divided it into small parcels, and called their development the New Jersey Fruit and Farm Colony. This map shows lots on Railroad Avenue east of Main Street. The company marketed its reasonably priced land and homes to both English- and Polish-speaking city dwellers who were delighted to move to the country and the fertile soil of Whitehouse, where they could grow and raise their own food. The influence of these Polish immigrants can still be seen in Whitehouse Station, where Pulaski and Koscuisko Roads, named after Polish heroes of the American Revolution, are major thoroughfares.

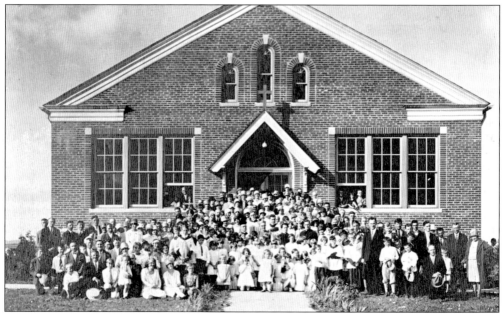

In December 1922, Bishop Thomas J. Walsh assigned Fr. Mieczyslaw Konopka to investigate the need for a new church in the Whitehouse Station area. When he reported that there were over 100 families, Konopka was appointed the first pastor of the new parish on June 10, 1923, and mass was celebrated in a local barn. Groundbreaking for the original church was held on August 19, 1923, and Our Lady of Lourdes Roman Catholic Church was completed on November 29.

The grotto for Our Lady of Lourdes Roman Catholic Church was completed in 1954. A 1936 dump truck and a 1938 truck were used to carry the boulders from Cushetunk Mountain to the grotto site. A gin pole was used to hoist the one-ton or larger rocks into place. The grotto was modeled after Lourdes while the statue of the Virgin Mary was sculpted in Italy of Carrera marble.

This wood-shingled water tank was used to store water in order to fight local fires. Residents were charged a 3¢ to a 5¢ tax for this service. However, it was clear to all that the tower leaked, as evidenced in the wintertime photograph at right of the frozen, escaping water and the freely flowing water in the summer scene below. Most townsfolk were not pleased to be paying for the flawed water containment system except for at least one young man seizing an opportunity to cool off on what must have been a hot summer's day.

Photographed in the summer of 1955 doing "what kids did in the summer" is Whitehouse Station resident Edward Schuetz enjoying the refreshing waterfall.

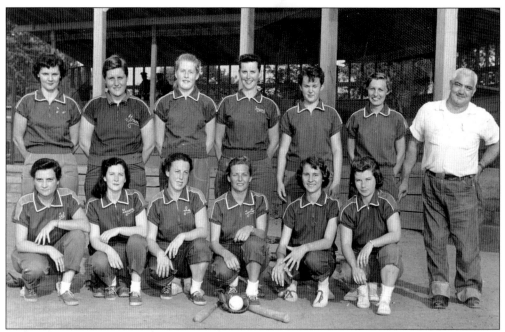

Matilada Vladich (first row, left) poses with the members of the 1956 Whitehouse Ramblers women's softball team in front of the old grandstand at the Brown Ingram Memorial Field. In the early 1950s, it was difficult for the Ramblers to find suitable teams to play, so they often played the women of the nearby correctional facility.

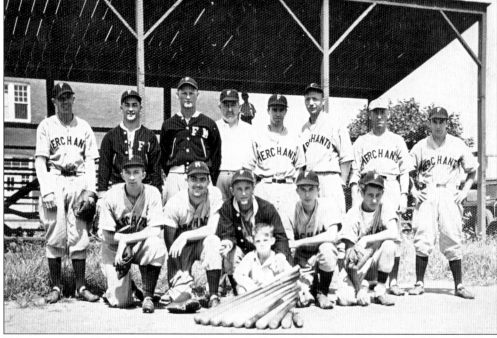

Taken around 1935, this photograph shows players Zip Landon (second row, second from left) and Russell "Pepper" Landon (second row, far right) posing with other members of the Whitehouse baseball team, the Merchants.

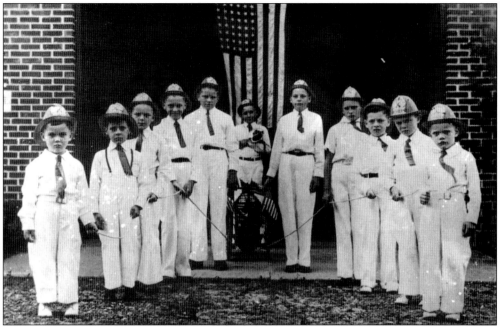

Organized by V. F. Roche, the junior fire company stands in front of the Whitehouse Station firehouse on July 4, 1942. Pictured from left to right are Ronald Londen, Russell Edinger, John Hendershot, Bill Bishop, Connie Lattourette, Floyd Bishop Jr., Dan Bush, Chickie Dilley, Jim Houghton, Leonard Smeaton, and Vincent Roche III.

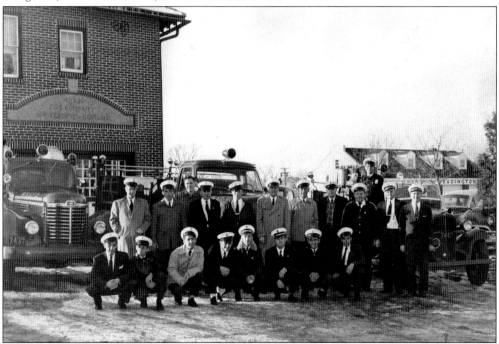

The members of the Whitehouse Station Fire Department are photographed during the 1950s. Among those pictured are J. Landon, C. Hackman, E. Brown, ? Prawl, B. Dillon, B. Lance, J. Sinabaldi, M. Zantowski, F. Bush, V. F. Roche Jr., C. Passeralla, C. Bush, and C. Latourette.

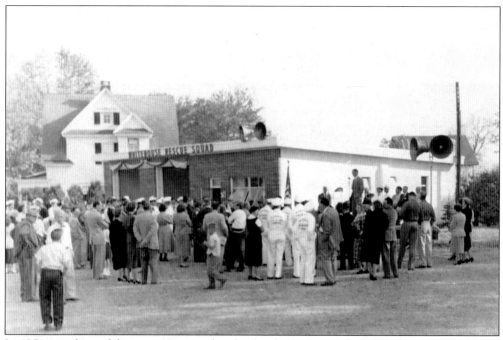

In 1954, members of the community gather for the dedication of the Whitehouse First Aid and Rescue Squad building on Route 22 and School Road.

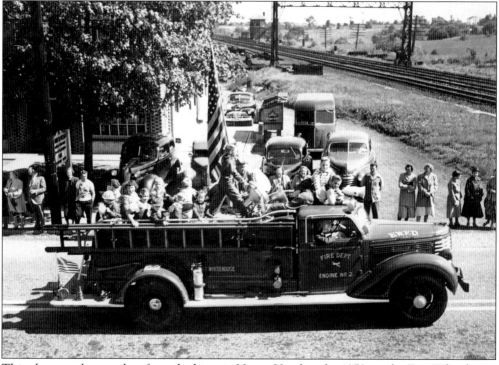

This photograph was taken from the historic Union Hotel in the 1950s as the East Whitehouse fire truck travels south on Main Street in Whitehouse Station during the annual Memorial Day parade.

Walter Lance Sr., postmaster at the Whitehouse Station Post Office, is shown assisting young customers with their annual letters to Santa Claus. The Whitehouse Station Post Office always had a little red box for letters to Santa positioned at the children's height. Most children on the rural delivery route left their letters in home mailboxes, while a visit to "town" allowed a Santa letter to be deposited in the wonderful red box. No matter who the child was or how little the identification was on the letter, every child received a response. Answers were written by Cora or Evelyn, who worked in the post office. When the current Whitehouse Station Post Office opened, the beloved red box disappeared. The letter at right was written by Walter "Bucky" Lance Jr., the son of the postmaster, when he was eight years old.

Dec. 18, 1933

Dear Santa,
How are you? I am fine this year and I sill want some toys this year I want as follows: — a scooter car. car of any kind. train of any kind. Gloves. and if you want me to have any more leave them, it is ok. with me.
I wish you a Merry Christmas and a Happy New year
Yours Truly,
Walter Lance Jr
Whitehouse N.J.

age-8

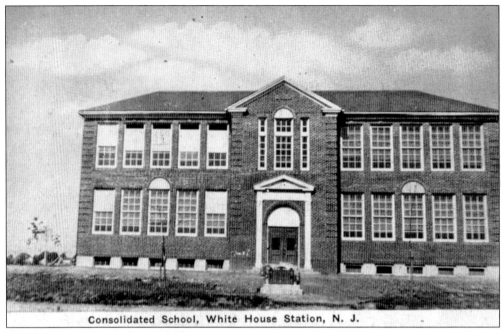

Consolidated School, White House Station, N. J.

The new consolidated school at Whitehouse Station was built in 1918. Students from Readington Township went on to attend Flemington High School.

Seated with their teachers are the members of the eighth-grade graduating class of Whitehouse Station School around 1948 or 1950.

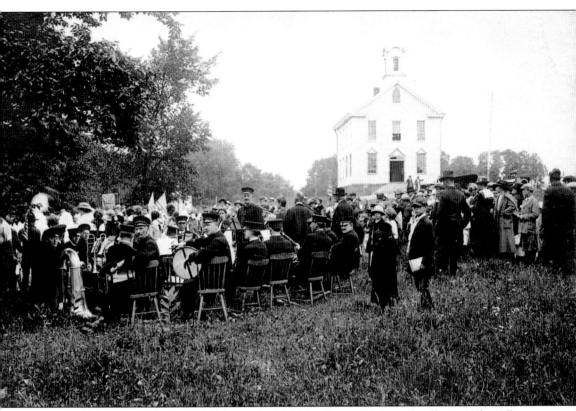

A large celebratory gathering is held outside the Whitehouse Station schoolhouse. The village schools were centers of community life. This schoolhouse is located on County Route 523 just north of the village. Two small schoolhouses preceded this one. Young students occupied the first floor while the older ones climbed the steps to the second floor. Today it is a private residence.

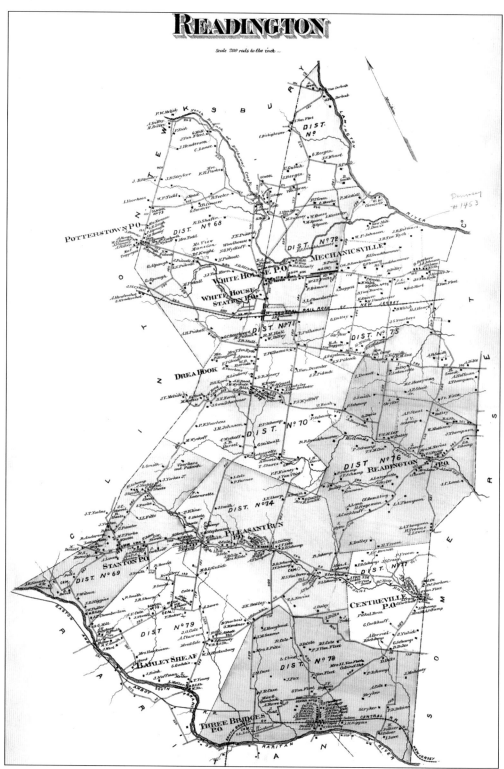

This is an 1873 map of Readington Township.

BIBLIOGRAPHY

Durling, C. *The Durlings of Whitehouse, a Family History*. Whitehouse, NY: Self-published, 2004.

Lequear, J. W. *Traditions of Hunterdon, Traditions of Our Ancestors*. Flemington, NJ: D. H. Moreau, 1956–1957.

Schmidt, H. G. *Rural Hunterdon, an Agricultural History*. New Brunswick, NJ: Rutgers University Press, 1945.

Snell, J. P. *History of Hunterdon and Somerset Counties, New Jersey, with Illustrations and Biographical Sketches of Its Prominent Men and Pioneers*. Philadelphia: Everts and Peck, 1881.

Stevens, S. *Forgotten Mills of Readington*. Bound Brook, NJ: Supreme Lithographers, 1987.

———. *For a Better Life, a History of the Polish Settlement in Readington Township*. White House Station, NJ: Merck and Company, 1990.

———. *Outcast, a Story of Slavery in Readington Township, Hunterdon County, New Jersey*. White House Station, NJ: Merck and Company, 2003.

Three Bridges Reformed Church. *History of Three Bridges Reformed Church, 1873–1973*. Three Bridges, NJ: Consistory, 1973.

Wealth and Industries of Hunterdon, Morris & Somerset Counties. Philadelphia: Pennsylvania Publishing Company, 1891.

ACROSS AMERICA, PEOPLE ARE DISCOVERING SOMETHING WONDERFUL. *THEIR HERITAGE.*

Arcadia Publishing is the leading local history publisher in the United States. With more than 3,000 titles in print and hundreds of new titles released every year, Arcadia has extensive specialized experience chronicling the history of communities and celebrating America's hidden stories, bringing to life the people, places, and events from the past. To discover the history of other communities across the nation, please visit:

www.arcadiapublishing.com

Customized search tools allow you to find regional history books about the town where you grew up, the cities where your friends and family live, the town where your parents met, or even that retirement spot you've been dreaming about.